IMAGES
*of America*

# THE BILTMORE ESTATE
## GARDENS AND GROUNDS

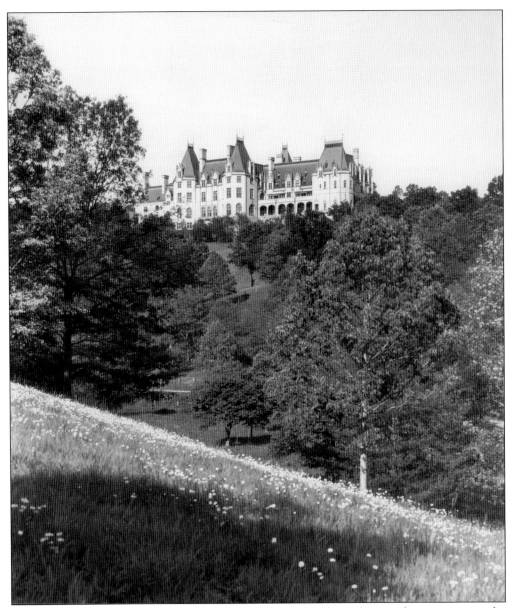

**BILTMORE HOUSE FROM THE DEER PARK, 1930.** Daisy-filled meadows and tree groves in the 250-acre Deer Park designed by landscape architect Frederick Law Olmsted provide a pastoral setting from which to view the imposing west facade of Biltmore House. (Courtesy of the Biltmore Estate Archives.)

**ON THE COVER: BILTMORE HOUSE, EAST ELEVATION, C. 1910.** The formal Esplanade, framed by allées of tulip poplars, and adjacent gardens provide an elegant but simplistic foreground to present the ornate features of Biltmore House. Architect Richard Morris Hunt designed the 250-room French Renaissance–style chateau for George Washington Vanderbilt in the early 1890s and collaborated with landscape architect Frederick Law Olmsted in planning the various amenities on the estate. (Courtesy of the Biltmore Estate Archives.)

# IMAGES
## *of America*
# THE BILTMORE ESTATE
## GARDENS AND GROUNDS

Bill Alexander

ARCADIA
PUBLISHING

Published by Arcadia Publishing
Charleston, South Carolina

Printed in the United States of America

Library of Congress Control Number: 2015949614

For all general information, please contact Arcadia Publishing:
Telephone 843-853-2070
Fax 843-853-0044
E-mail sales@arcadiapublishing.com
For customer service and orders:
Toll-Free 1-888-313-2665

Visit us on the Internet at www.arcadiapublishing.com

*To all my colleagues in Biltmore Estate's Museum Services Department, fellow employees, and friends who share my love for Biltmore's incredible history and enduring beauty*

# CONTENTS

Acknowledgments 6

Introduction 7

1. A Vision Is Born 9

2. Breaking Ground 23

3. The Approach Road 37

4. The Home Grounds and Gardens 55

5. The Glen and Deer Park 91

6. A Model Farm and Forest 113

7. A Tribute to Chauncey Beadle 123

# ACKNOWLEDGMENTS

To illustrate the beauty and diversity of Biltmore Estate's gardens and grounds, this volume includes a mix of previously published photographs and many new images from a variety of sources that are published for the first time. It is my wish that all who open its covers will see Biltmore in a new light and appreciate the extraordinary vision, creativity, and artistry of its founder, George Washington Vanderbilt, and his architects, engineers, managers, and workers who labored together to make the estate the special place it remains more than a century later. A book such as this would not be possible without the generosity and assistance of many others who work behind the scenes in various capacities. I wish to thank all of the institutions and individuals who have provided copies of archival images and permission to use them in this book. There were far more photographs than room to include. Special thanks go to Michele Clark at the Frederick Law Olmsted National Historic Site; Gene Hyde and Colin Reeve at Special Collections, Ramsey Library, UNC Asheville; and Zoe Rhine and other staff at the North Carolina Collection, Pack Memorial Library for generously making photographs in their collections available. I owe much gratitude to several of my colleagues in Biltmore's Museum Services Department, particularly archivist Jill Hawkins for her patience and tedious efforts in formatting the many images and assistance with obtaining photographs from various institutions. Additionally, I would like to thank Biltmore's associate archivist Winnie Titchener, chief curator Darren Poupore, curator of interpretation Leslie Klingner, curatorial assistant Lori Garst, and my director, Ellen Rickman, for all their willing support and assistance when I needed it. I am grateful to my contacts Katie McAlpin-Owens and Stacia Bannerman at Arcadia Publishing for their generous patience while I was working on this book. I want to thank God for the ability to do all that I do, and last but not least, I owe special thanks to my dear wife, Jackie, for her love, understanding, and never-ending support.

Unless otherwise noted, all images appear courtesy of Biltmore Estate Archives. For sake of concision, images courtesy of the National Park Service, Frederick Law Olmsted National Historic Site are designated as (FLONHS) and images courtesy of Special Collections, D.H. Ramsey Library at UNC Asheville are designated as (RLUNCA).

# INTRODUCTION

Biltmore Estate stands out as one of the greatest of the country estates created during not only the Gilded Age but also any period before or since. The details of how it happened and of all who were involved would fill volumes, well beyond the scope of this book. By all accounts, the project started out happenstance, at least initially. The estate's proprietor, George Washington Vanderbilt, seems to have conceived the idea and decided he wanted to buy land and build a residence all while on an extended vacation in Asheville. After returning to his home in New York, Vanderbilt sent his agent to the Western North Carolina mountains to begin quietly buying up parcels of land that were on the market at a cheap price. His architect, Richard Morris Hunt, started drawing plans for several different residences in terms of style and size without having first set foot on Vanderbilt's North Carolina property. Vanderbilt even admitted to his landscape architect, Frederick Law Olmsted, that he was buying many tracts of land without any clear purpose or idea of what he was going to do with his property.

Little evidence has been found to as to whether Vanderbilt considered other areas to build a home or if he was even thinking about building one at all. As the youngest of eight children, he was still living at the family home in New York. After the death of his father, William Henry Vanderbilt, in 1885, young George inherited a life interest in the family residence and furnishings at 640 Fifth Avenue in New York, which he would receive upon the death of his mother, Maria Louisa Kissam Vanderbilt. He had purchased a summer place in Bar Harbor, Maine, he called Pointe d'Acadie. As for a country property, George had inherited Homestead, the family's Staten Island estate. Yet there are stories in southwestern Virginia that George Vanderbilt's first choice of a location to build a home was an area known as Burke's Gardens, but none of the residents wanted to sell land to him. No documentation has been found to substantiate this claim.

Even within the confines of the theme, Biltmore Estate's gardens and grounds, chosen for this book, justice cannot be done to the incredible story and extensive details involved with their design and creation. For the 211 images chosen to tell the story, hundreds more exist. There are thousands of pages of correspondence and other materials in the Biltmore archives, less than a fourth of which has been processed. Additionally, the Olmsted Papers and Olmsted Associates Records housed in the manuscript division at the Library of Congress and the archives at the Frederick Law Olmsted National Historic Site could provide enough research material to fill several volumes about Biltmore and a life's work on this very subject.

Biltmore Estate came at the end of Frederick Law Olmsted's career as a landscape architect, and one gets the feeling that he felt it was special and one of the most important of his undertakings. Perhaps Olmsted sensed that Biltmore would be his last hurrah or else he poured his heart and soul into the project because he knew what it would mean for his profession of landscape architecture. At any rate, he must have felt that Biltmore would become his crowning jewel, and this prompted him to write his young partner Henry Codman in October 1890, "I should like to give myself up to this place." He basically did just that, as Biltmore dominated the last seven years

of his professional career. It also may have had something to do with the fact that 40 years earlier he had been a neighbor of George Vanderbilt's father on Staten Island and was already working with George on the Vanderbilt family mausoleum at New Dorp, Staten Island, and planning the grounds of Pointe d'Acadie.

Biltmore challenged Olmsted in several ways. One was how to successfully mesh his naturalistic landscaping style with Hunt's formal and often elaborate architectural elements. It is not that Olmsted was averse to formal elements, as he had designed formal spaces in some of his public park designs. For the project to be successful, it would require close collaboration with Hunt, Vanderbilt, and other key people. A second challenge was that for much of the time he was working on Biltmore, Vanderbilt kept buying additional land and expanding the estate, so that made it difficult to develop a finished plan at one time. Thirdly, Olmsted's health was progressively worsening during the years he was working with Biltmore. In spite of these things, Olmsted appointed himself as the lead partner in charge of the Biltmore project and tried to keep on top of all the different directions it was taking him. He almost became obsessed with two of his largest, and most controversial, undertakings at Biltmore—that of making the estate a model of forestry for the country and developing the grand arboretum that he proposed to Vanderbilt. With time however, Olmsted became more frustrated as he saw a waning enthusiasm and decline in Vanderbilt's and other's support for the arboretum. The arboretum project did hold on a little longer than five years after Olmsted's forced retirement due to his health. In 1901, nurseryman Chauncey Beadle reported that Vanderbilt had decided to abandon the idea of a large-scale scientific arboretum, making it the only major component of Olmsted's plan that did not get carried out to fruition.

Olmsted's success with Biltmore is greater than can easily be measured. His vision was extraordinary and far-reaching and often ahead of his time. Some of his concepts in forest management and land restoration are now being rediscovered. The park areas, lakes, and the Approach Road are still serving the purpose intended for them well over a century later. Early in the project, as work on the Approach Road was still progressing, Richard Morris Hunt remarked on Olmsted's success with it: "Hasn't Olmsted done wonders with the Approach Road? It alone will give him lasting fame . . . If only Burnett, Pinchot, and I succeed as well, what a blissful time is ahead for George in the fulfillment of his ideas; may he live to a ripe old age to enjoy his and our work."

During the period from 1888 through the early 1900s that Frederick Law Olmsted Sr. and his firm worked on the Biltmore project, the name of the firm changed several times due to the status of its partners. Within a few years after Olmsted Sr.'s retirement, his sons John C. Olmsted and Frederick Law Olmsted Jr. changed the name to Olmsted Brothers.

The focus of this book is primarily on the portion of Biltmore's gardens and grounds that can be accessed by today's guests to the estate. The emphasis is on the overall design intent and the implementation of an extraordinary world-class landscape during the first half of more than a century of existence. The first two chapters cover the vision for the estate and some of the key people involved, breaking ground, and early stages of construction. The key areas covered are conveniently grouped using the divisions in Olmsted's master plan—the Approach Road, the Home Grounds and Gardens, the Glen and Deer Park, and the farm and forest. Forestry and the agricultural enterprises are introduced, but room would not allow a comprehensive look at those areas. A whole volume would be needed to do justice to those topics. Lastly, a short chapter pays tribute to Chauncey Beadle for his contributions over more than half a century.

# One

# A VISION IS BORN

In the winter of 1887–1888, George Washington Vanderbilt, his recently widowed mother, Maria Louisa Kissam Vanderbilt, and other family members vacationed in Asheville, North Carolina, for a period of several weeks. With ample time on his hands, Vanderbilt took advantage of long rides in the countryside around Asheville and was drawn to an area south of town where a number of small farms and vacant tracts of sparsely wooded land were for sale near a railroad station. He found the air "mild and invigorating," the climate to his liking, and the scenic beauty of the distant mountains inspiring. So the germ of an idea was born. He would need to assemble a team of experts to advise him and help develop his ideas into a viable plan. Vanderbilt returned home to New York and started corresponding with prospective architects and other specialists. His initial team included Richard Morris Hunt as his architect, Frederick Law Olmsted as his landscape architect, Edward Burnett to advise him on agricultural matters, and his friend and attorney Charles McNamee to manage land acquisitions, business organization, construction management, and legal affairs.

After McNamee moved to Asheville and set up a base of operations and office, he began acquiring tracts of land for Vanderbilt as rapidly as possible. Site visits for Olmsted, Hunt, and Burnett were arranged to gather information and begin formulating conceptual plans. Arrangements needed to be made with local surveyors, engineers, and other consultants. Important issues such as water sources, location of suitable veins of stone for building and road surfacing, deposits of clay for brickmaking, and other infrastructure needed to be solved. Thus, in fairly short order, a vision for Vanderbilt's estate was born.

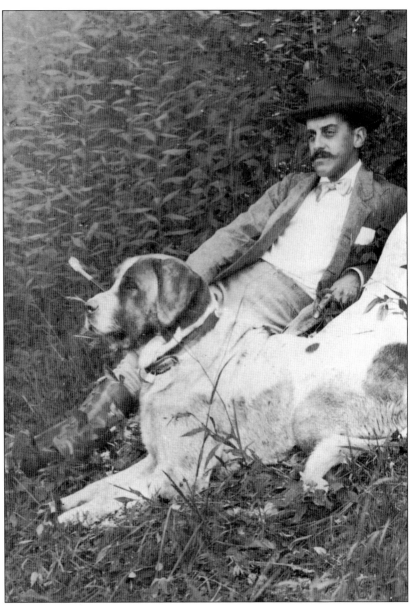

**GEORGE W. VANDERBILT AND SAINT BERNARD, JUNE 1896.** George Vanderbilt seems to be enjoying an outing with one of several Saint Bernards he owned at various times. Eight years had passed since his first visit to Asheville and the surrounding region and his decision to begin purchasing land to build his residence. By the time this photograph was taken, Vanderbilt had expended millions of his inheritance to create the largest and grandest country estate in America. His property consisted of some 125,000 acres, about 195 square miles, and spread over parts of four counties of Western North Carolina. Elevations ranged from around 2,000 feet above sea level along the French Broad River to more than a mile high on Mount Pisgah. From his house, Vanderbilt's holdings stretched nearly 40 miles to the estate's farthest boundary. His total acreage was divided into three primary tracts consisting of the main estate, a vast stretch of the Blue Ridge Mountains that he called Pisgah Forest, and a watershed on Busbee Mountain, just southeast of his residence.

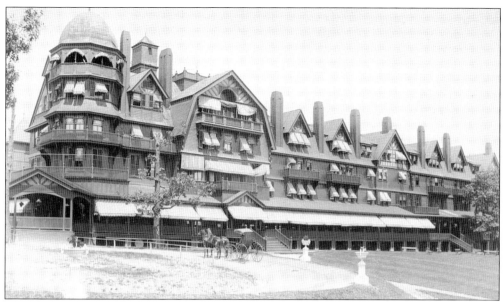

**BATTERY PARK HOTEL, C. 1895.** George Vanderbilt, his recently widowed mother, Maria Louisa Kissam Vanderbilt, and other family members arrived in Asheville in November 1887. The parties checked into the elegant Battery Park, a grand Victorian resort hotel completed the year before on Battery Porter Hill, the highest point in town. Local papers reported that the group required seven rooms and planned on staying several weeks.

**GEORGE VANDERBILT AND UNIDENTIFIED GUESTS, 1906.** While vacationing in Asheville, Vanderbilt had ample time to explore the hills and valleys in the surrounding region. He seemed to be drawn to an area a few miles south of town near the village of Best, or Asheville Junction, at the confluence of the Swannanoa and French Broad Rivers. It was here that the Western North Carolina Railroad first arrived in 1880.

**LONE PINE MOUNTAIN, c. 1888.** Exploring the countryside, George Vanderbilt found the air "mild and invigorating" and the climate to his liking. He later described his experience: "I took long rambles and found pleasure in doing so. In one of them I came to this spot under favorable circumstances and thought the prospect finer than any I had seen. It occurred to me that I would like to have a house here."

**POOR WOODLAND, c. 1892.** Although the immediate surroundings had frequently been slashed, burned, and overgrazed for a century since settlement, Vanderbilt imagined that the land could be improved over time. He observed that numerous tracts lay vacant and were on the market at a cheap price. If he could quietly buy a number of these tracts, he would have the beginning of a sizeable estate with no close neighbors.

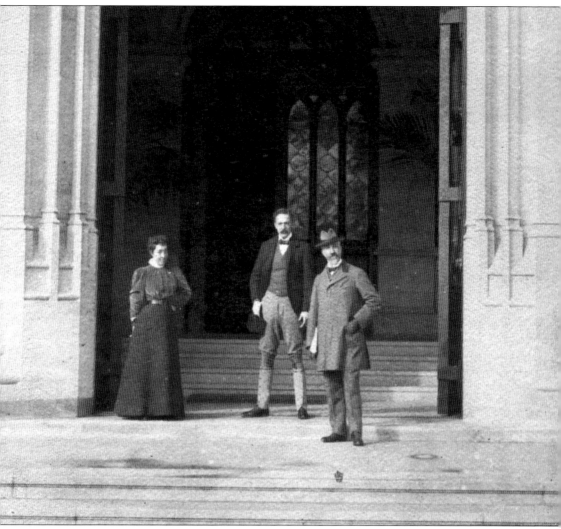

**Charles McNamee and Unidentified Guests, c. 1896.** Upon returning to New York in the early spring of 1888, George Vanderbilt sent his agent Charles McNamee to begin purchasing available tracts of land in his own name so no one would suspect a millionaire was buying up the land. McNamee earned a law degree from Columbia University and practiced law with his elder brother James in New York and managed George W. Vanderbilt's Staten Island properties. McNamee's first visit to the Asheville was on May 1, 1888. He moved with his wife, Julia Austin Lord, to Asheville in 1889 when he built his residence in the suburb of Victoria and called it Old Ford, referring to the view he had of the old fording place on the Swannanoa River. McNamee was president of the Biltmore Brick and Tile Works, the Biltmore Lumber Company, the Asheville Woodworking Co., and North Carolina's Agricultural Society (1900). As estate superintendent, he became the center of control, with all department supervisors reporting to him. McNamee (right) is pictured here with two unidentified guests. (Courtesy of Lila Wilde Berle.)

**FARMS ALONG THE FRENCH BROAD RIVER, C. 1889.** By the end of 1890, George Vanderbilt had acquired around 6,000 acres. In time, he purchased more than 600 individual parcels of land totaling over 55,000 acres in Buncombe County. The purchase of two large tracts and numerous smaller ones in three other counties increased his holdings to 125,000 acres. On the main estate, the various parcels ranged in size from an acre to several hundred acres. Many of the farms in the more fertile bottomlands along the rivers were prone to periodic flooding, and those on the ridges had soils that were easily eroded when cleared. Decades of culling the land of its best trees for lumber, fence posts, and firewood along with frequent wildfires and overgrazing had left much of the land in a degraded condition.

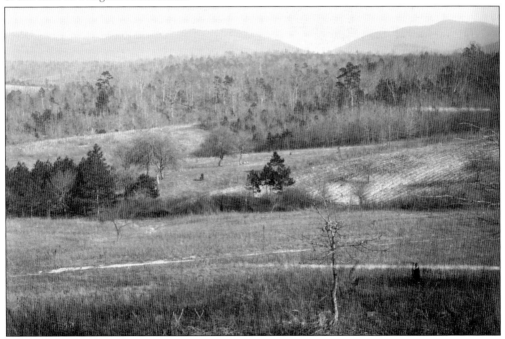

**RICHARD MORRIS HUNT PORTRAIT, 1895.** George Vanderbilt chose noted architect Richard Morris Hunt to design his residence. Hunt was the first American known to have studied at the École des Beaux-Arts in Paris. Hunt's designs include the base for the Statue of Liberty, the Tribune Building in New York City, the Great Hall of the Metropolitan Museum of Art, and homes for prominent American families, including the Vanderbilts. Hunt initially offered George Vanderbilt several alternative designs, including the more modest and conventional styles of Colonial Revival and Tudor. Hunt had designed a French Renaissance–style house for one of George's brothers, William K. Vanderbilt, at 660 Fifth Avenue in New York and suggested similar options for George. After a two-month trip to England and France with Vanderbilt in the summer of 1889, the scheme for the 250-room chateau was born. Vanderbilt brought John Singer Sargent to the estate in May 1895 to paint portraits of its creators. Hunt died on July 31 of that year, before the completion and formal opening of Biltmore House on Christmas Eve.

**FREDERICK LAW OLMSTED PORTRAIT, 1895.** Vanderbilt commissioned Frederick Law Olmsted to help him plan and lay out the extensive grounds on his estate that he would call Biltmore. Often referred to as "Father of American Landscape Architecture," Olmsted is noted for his numerous landscape designs, including New York's Central and Prospect Parks, Niagara Falls and Buffalo Parks, Boston's "Emerald Necklace," redesign of the Capitol grounds, Louisville parks, and many others. Just as for Hunt, Biltmore would become Olmsted's last major project and was considered by him as "by far the longest, most difficult, and complicated work that we have; [and] will have the largest future importance and celebrity." He saw Biltmore as a critically important commission for his young partners, Henry Sargent Codman and Olmsted's stepson John C. Olmsted. For them he predicted, "This work will, twenty years hence, be what Central Park has been for me—the first great private work of our profession in the country." Due to his failing health, Olmsted departed Biltmore for the last time in the summer of 1895, before Sargent completed this portrait.

**GEORGE VANDERBILT AND CONSULTANTS, 1892.** Pictured here are, from left to right, agricultural consultant Edward Burnett, architect Richard Morris Hunt, landscape architect Frederick Law Olmsted, George W. Vanderbilt, and architect Richard Howland Hunt, son of Richard Morris Hunt. Other professionals involved the creation of Biltmore include supervising architect Richard Sharp Smith, landscape architects Frederick Law Olmsted Jr. and John C. Olmsted, and horticulturist Chauncey D. Beadle.

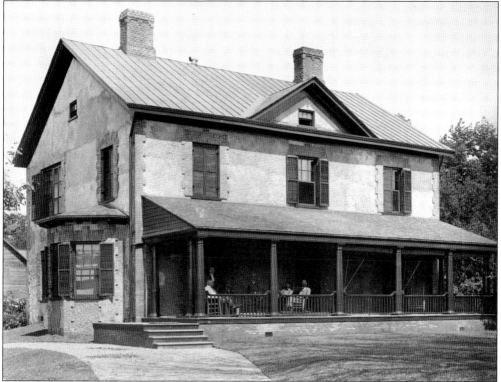

**BRICK FARMHOUSE, C. 1892.** George Vanderbilt purchased two adjoining farms from W.J. and B.J. Alexander along the French Broad River and renovated the lower Alexander house shown here so that he, his consultants, and other guests had a place to stay on-site during construction. R.M. Hunt is seated on the far left, Vanderbilt in the center, and agricultural consultant Edward Burnett on the far right.

**SITE OF BILTMORE HOUSE AND VIEW FROM SCAFFOLD, 1889.** Olmsted played a key role in siting the house and its amenities. He wrote to Vanderbilt on July 12, 1889, "The principal points of the residence and its dependences, as the plan stood when you went away, have been marked on the ground by stout stakes, and two scaffolds have been erected from one of which the view from

the Music Room window can be had, from the other the view from the south end of the Terrace. I think that you will be pleased to find how much is to be gained by setting out the building well over the hillside as advised by Mr. Hunt, and also what a considerable variation of view will be had by walking to the end of the Terrace."

**FLOODED BOTTOMLANDS ON PREEXISTING FARM, C. 1889.** Vanderbilt's initial thought was to create an extensive park on his property similar to those he had seen at great country estates in America and Europe, but Olmsted thought much of his land was too rough and poor for a proper park. He expressed to his client, "You bought the place then simply because you thought it had a good air and because, from this point, it had a good distant outlook. If this was what you wanted you have made no mistake. There is no question about the air and none about the prospect. But the soil seems to be generally poor. The woods are miserable, all the good trees having again and again been culled out and only runts left. The topography is most unsuitable for anything that can properly be called park scenery. It's no place for a park. You could only get very poor results at great cost in attempting it."

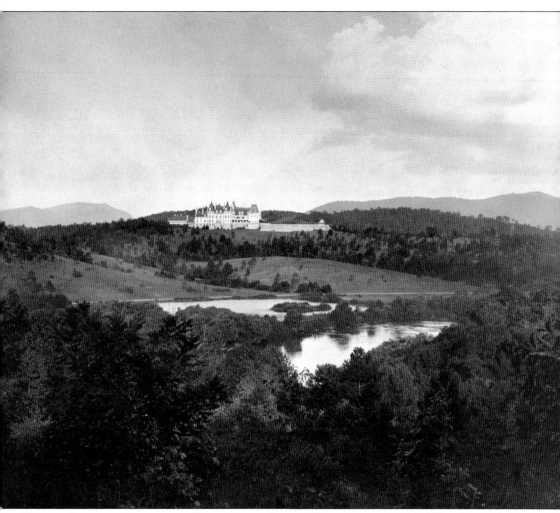

**VIEW OF FORESTED ESTATE FROM WEST SIDE OF FRENCH BROAD RIVER, 1900.** When Vanderbilt asked what he should do with all of his acreage, Olmsted advised, "Such land in Europe would be made a forest; partly, if it belonged to a gentleman of large means, as a preserve for game, mainly with a view to crops of timber. That would be a suitable and dignified business for you to engage in; it would, in the long run, be probably a fair investment of capital and it would be of great value to the country to have a thoroughly well organized and systematically conducted attempt in forestry made on a large scale. My advice would be to make a small park into which to look from your house, make a small pleasure ground and garden, farm your river bottom chiefly to keep and fatten livestock with a view to manure, and make the rest a forest, improving the existing woods and planting the old fields." Olmsted believed that a well-managed forest would be the best use Vanderbilt could make of his land.

**BILTMORE NURSERY, OCTOBER 15, 1895.** Olmsted suggested, "Many of the trees, shrubs and vines that you will find it desirable to plant in considerable quantity cannot be found at the commercial nurseries; certainly cannot except in small numbers and at the price of rarities." Larger quantities would be needed however, than could "be obtained at this time from all the nurseries in the country or . . . of Europe." He opined, "Propagating and rearing them on a scale large enough to warrant the employment of a good gardener with a suitable plant for the purpose, they would cost you not a quarter as much as the commercial price." Additionally, he saw an opportunity to create a major arboretum on the estate as an outdoor museum of trees, complete with a botanical library and herbarium, where dendrologists, botanists, and landscape gardeners could study and learn. (Both, courtesy of FLONHS.)

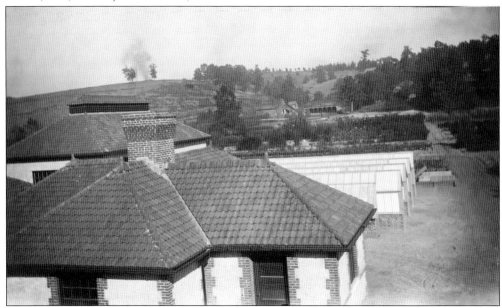

# Two

# BREAKING GROUND

In order to get such a large-scale project up and running, a lot of groundwork had to be laid. Estate superintendent Charles McNamee had to establish a base of operations and office. He also established a couple of "captive companies," a brick and tile works and a woodworking company for manufacturing needed materials. The brickworks and estate office were located in the adjacent village of Best, convenient to the railroad, post office, and businesses. McNamee worked with Vanderbilt to select several preexisting houses on some of the tracts he had purchased to renovate for quarters when Vanderbilt and his consultants came to Asheville. Others were fitted as residences for key people whose services were needed daily for the duration of the construction period of almost seven years. These included supervising architect Richard Sharp Smith, landscape and forest manager James Gall Jr., and farm manager Baron Eugene d'Allinges. Soon other cottages were constructed to house the head gardener, chief forester, and manager of the Sheep Farm.

Other infrastructure needs had to be established. First and foremost was an ample supply of good water to the construction site. Clay deposits to supply the brickworks and a quarry site to obtain stone suitable for building and road surfacing needed to be located as conveniently as possible. Plans for a spur railroad to the construction site to transport the massive amounts of building materials would have to be developed. Then, of course, much effort would need to be expended to contract with suppliers of tools, machinery, and materials for a steady stream of goods. Surveyors and engineers needed to be interviewed and hired to begin mapping Vanderbilt's holdings for work to begin. In many ways, this early period of breaking ground was most critical to the success of the entire project.

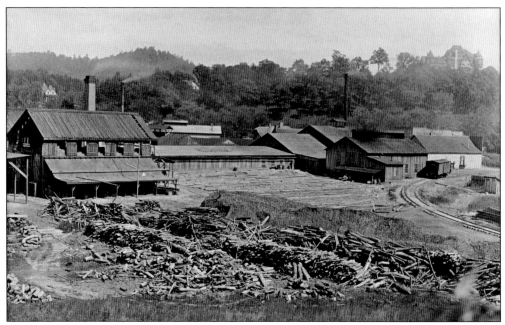

BILTMORE BRICK AND TILE WORKS, C. 1894. Before construction could get underway, sources for a steady supply of building materials such as stone, brick, and lumber needed to be determined. Local sources, if available, would be more economical without the added costs of shipping long distances. When a site with suitable clay was found on Vanderbilt's property, estate superintendent Charles McNamee ordered brickmaking machinery and established the Biltmore Brick and Tile Works.

LODGE STREET BY BRICK AND TILE WORKS, OCTOBER 15, 1895. The brick and tile works was located just outside the main entrance to the estate and next to the Biltmore railroad line that was laid out to the construction site. By 1891, the brickworks produced on average 38,000 bricks per day. Machinery and dies for producing roofing tiles, hollowware, drain tiles, and flowerpots were added. (Courtesy of FLONHS.)

CLAY PITS, EARLY 1890s. A 36-inch narrow-gauge dummy line ran from the brickworks to the clay pits on the estate. By October 2, 1891, the small locomotive, which George Vanderbilt named *Ronda*, had arrived and made the first trip to the clay pits in six minutes. Side-dumping cars were used to haul the clay to the brickworks. (Courtesy of Tony D. Smith.)

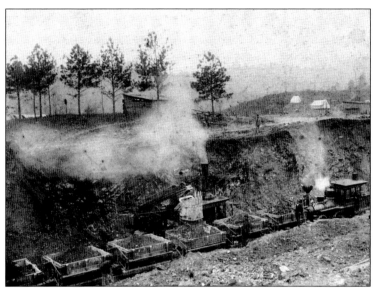

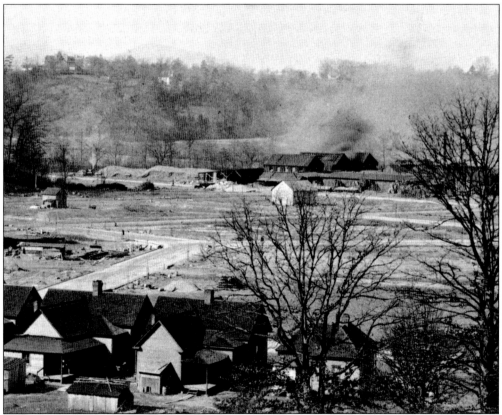

VIEW OF BRICKWORKS IN BILTMORE VILLAGE, LATE 1895 TO EARLY 1896. Piles of clay can be seen in the left center of this photograph along with *Ronda*, the small 36-inch Baldwin engine used to haul the clay to the brickworks. At the end of construction, the brickworks ceased operation. In late December 1898, McNamee reported selling the *Ronda* and the secondhand 20-pound rails that the *Ronda* had traveled.

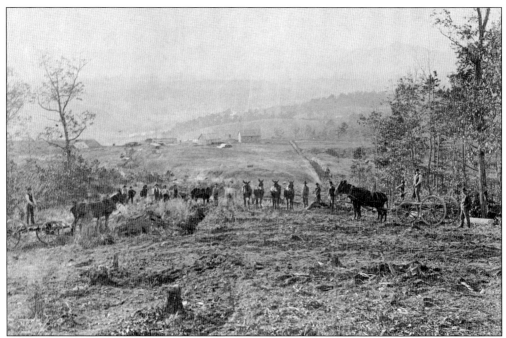

PREPARING THE SITE, 1890. Workmen and teams are clearing stumps and brush and beginning rough grading of the Vista site in the foreground. Preparations and staging for work crews and materials are visible beyond on the west end of the Esplanade. The railroad spur line can be seen on the left, while a deep trench on the right is probably for the water supply line that was turned on in mid-July 1890.

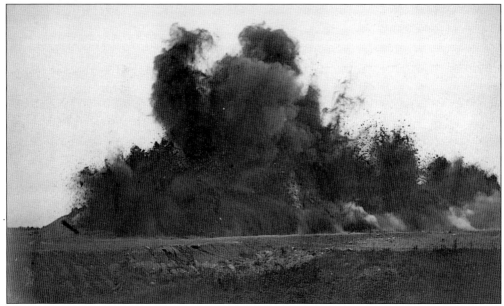

BLASTING ON THE ESPLANADE, AUGUST 1891. In late December 1889, estate superintendent Charles McNamee ordered 2,000 pounds of dynamite and 200 kegs of blasting powder. A 20-foot hilltop had to be blasted to remove an estimated 106,000 to 181,000 cubic yards of rock and soil to create the level grade of the Esplanade.

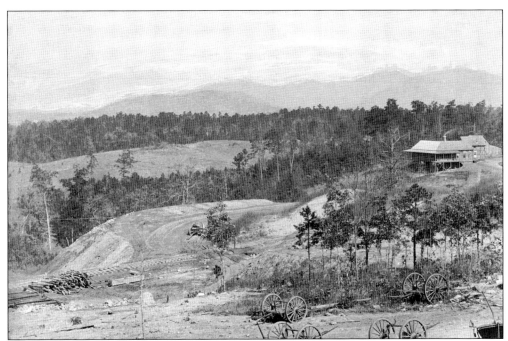

BILTMORE RAILROAD BY THE WEEKS HOUSE, OCTOBER 1890. Chief contractor F.M. Weeks with D.C. Weeks & Son lived in this house just north of the Esplanade until construction was completed. The railroad crossing of the Approach Road near this location was referred to as "Weeks' Crossing." In September 1894, the blacksmiths', carpenters', and painters' shops were relocated from the Esplanade and temporarily established near the Weeks stable.

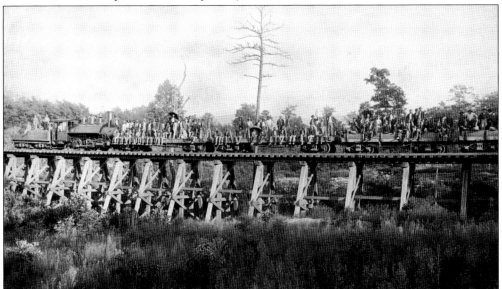

RAILROAD TRESTLE, C. 1892. The standard-gauge railroad line constructed to haul building materials and workmen from Biltmore Village to the Esplanade was 17,375 feet, or 3.29 miles, in length and gained 242 feet in elevation. It required five trestles totaling 1,052 feet in length to maintain the even grade over the hills and ravines. The total construction cost was $13,360. Center walk boards on the trestles were approved in February 1893.

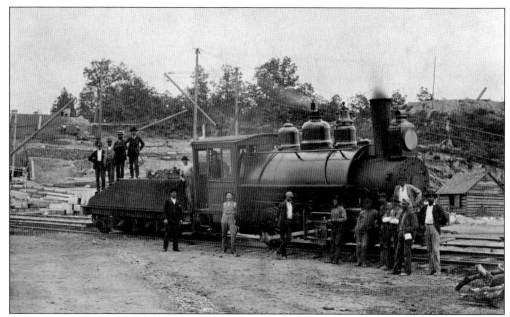

BALDWIN LOCOMOTIVE, 1892. This standard-gauge engine has the name "Biltmore" under the cab window. It became the workhorse of the three locomotives Vanderbilt purchased. The first Biltmore locomotive, Engine No. 75, was received from New York Central Railroad on October 21, 1890, but had to be modified because it lacked the coal and water capacity to make one trip to the Esplanade. It was later renamed *Cherokee*.

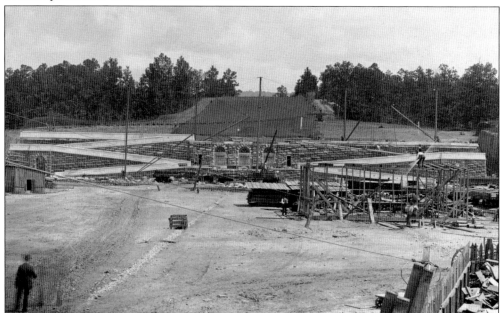

RAMPE DOUCE AND VISTA, 1892. Olmsted's instructions for work to be done in autumn 1891 included filling out the Vista and adjoining slopes east of the Esplanade and creating the inclined plane of unbroken turf 140 feet broad at the rear of the ramp and 130 feet broad at the point of junction of the diagonal vistas in preparation for planting trees on the borders. Note the temporary tram line.

VIEW OF ESPLANADE FROM VISTA, JULY 16, 1893. As soon as grading and construction was completed on any area of the grounds, the Olmsted firm would prepare instructions for finishing. In this view, the final grading of the Vista is complete, the double rows of linden trees planted on the borders, and a good stand of turf is being mown well before the second-floor walls of the house are done.

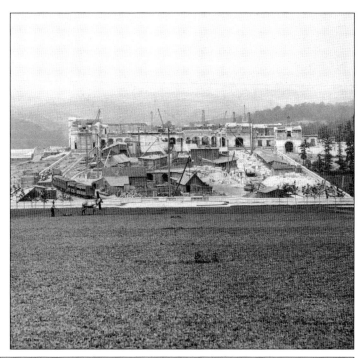

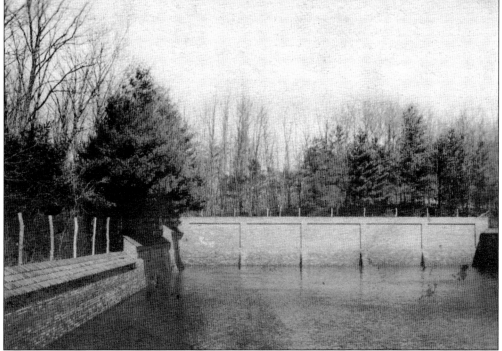

LONE PINE RESERVOIR, C. 1915. The main water supply from the reservoir on Busbee Mountain, some three miles southeast, had been supplying water to the estate since July 1890. With increased demands, the capacity of the supply would need expanding. Chauncey Beadle completed construction of this two-million-gallon storage reservoir on Lone Pine Hill east of the Vista in 1899. (Courtesy of the North Carolina Collection, Pack Memorial Library, Asheville.)

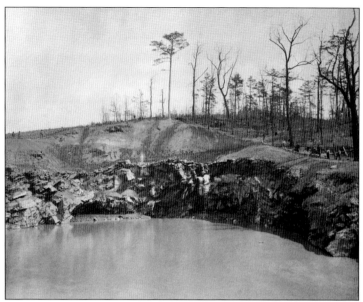

STONE QUARRY, C. 1895. From early 1891, this quarry adjacent to the Approach Road provided a large part but not all of the gneiss, a granite-like stone used for constructing bridges, garden walls, and parapets. If not used nearby, the stone was hauled on a tramway powered by a hoist engine to the Biltmore railroad, where it was loaded onto railcars. A stone crusher provided material for surfacing roads and paths. (Courtesy of FLONHS.)

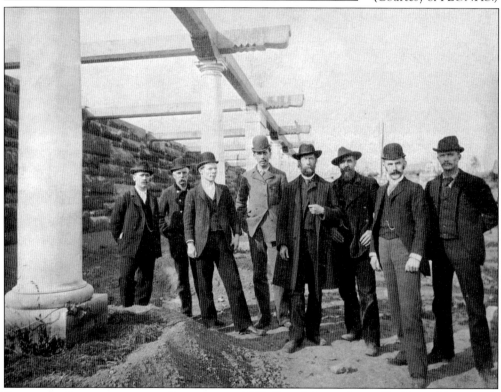

ENGINEERS, CONTRACTORS, AND SUPERVISORS, 1892. From left to right are J.L. Howard (engineer), George R. Olney (engineer), A.E. Schneeweiss (draftsman), E.C. Clark (probably an engineer), W.A. Thompson (chief engineer), F.M. Weeks (chief contractor), R.S. Smith (supervising architect), and J. Berrall (occupation unknown). In November 1889, Olmsted recommended that Thompson direct surveying and engineering operations and James Gall Jr. direct agriculture, horticulture, forestry, and gardening.

**CHAUNCEY D. BEADLE, 1906.**
A Canadian by birth, Beadle studied botany and horticulture at Ontario Agricultural College and Cornell University. The Olmsted firm hired him in 1890 to manage nursery operations, then under James Gall. In March 1894, George Vanderbilt separated the nursery from the landscape department and placed Beadle in charge of it and all planting operations as well. Under Beadle, the nursery began commercial sales in 1898.

**LANDSCAPING DEPARTMENT, MARCH 1, 1891.** Employees in the landscape department pause from their work on the Approach Road for this group photograph. Department head James Gall Jr., believed to be the man on horseback, had previously worked with Olmsted in Central Park. Most of Gall's integrated workforce was local. Olmsted, with the gray beard, is standing in the front row between Chauncey Beadle on left and George Vanderbilt on right.

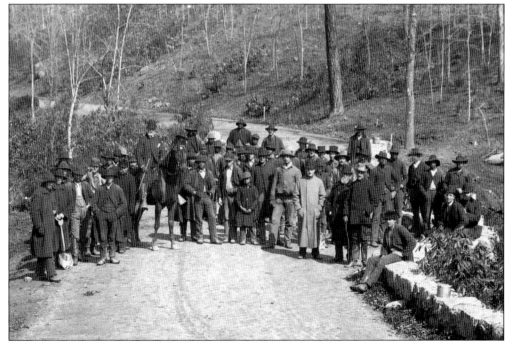

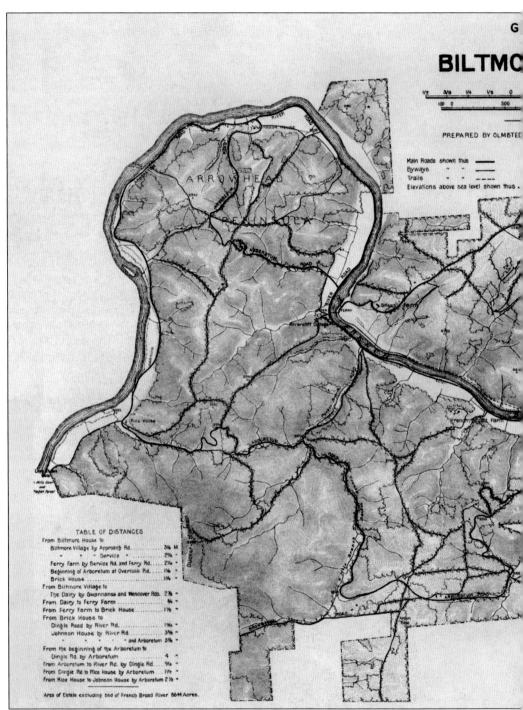

PREPARED BY OLMSTEC

Main Roads shown thus ——
Byways      "    "      ......
Trails      "    "      -- -- --
Elevations above sea level shown thus .

ARROWHEAD

PENINSULA

TABLE OF DISTANCES
From Biltmore House to
  Biltmore Village by Approach Rd. ......... 3½ M
  "      "      " Service " ............... 2½ "
  Ferry Farm by Service Rd. and Ferry Rd. .... 2½ "
  Beginning of Arboretum at Overlook Rd. .... 1¼ "
  Brick House ............................... 1½ "
From Biltmore Village to
  The Dairy by Swannanoa and Wendover Rds. 2⅞ "
  From Dairy to Ferry Farm .................. ¾ "
  From Ferry Farm to Brick House ........... 1½ "
From Brick House to
  Dingle Road by River Rd. ................. 1¾ "
  Johnson House by River Rd. ............... 3½ "
  "      "      "   " and Arboretum 3⅞ "
From the beginning of the Arboretum to
  Dingle Rd. by Arboretum .................. 4 "
  From Arboretum to River Rd. by Dingle Rd. .... ⅝ "
  From Dingle Rd. to Rice House by Arboretum .. 1½ "
  From Rice House to Johnson House by Arboretum 2½ "

Area of Estate excluding bed of French Broad River 8644 Acres.

GUIDE MAP OF BILTMORE ESTATE, 1896. Olmsted insisted that accurate topographical maps were needed to lay out the various elements of his comprehensive plan for the estate, which included the Home Grounds and Gardens, the Deer Park, ponds and lakes, carriage drives, vistas, and farming operations. Numerous versions of maps at various scales were created over time. This guide map was created and printed as a way-finding map for guests on the estate. Road names

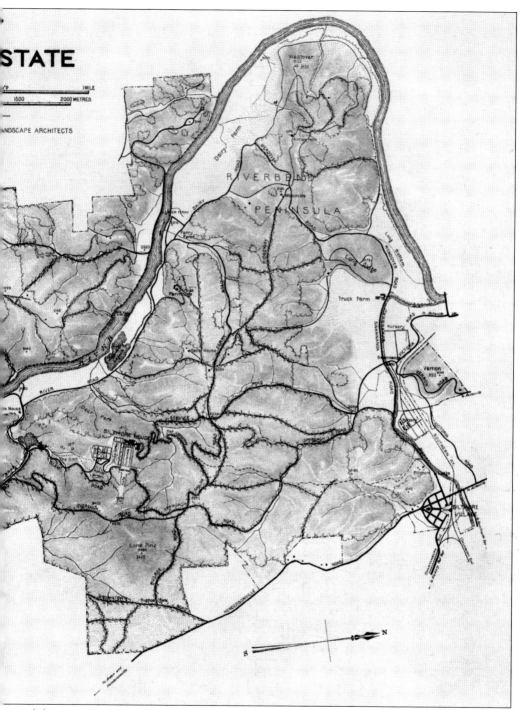

LANDSCAPE ARCHITECTS

and distances are shown as are locations of the ferries, buildings, farms, primary streams, and elevations. Biltmore House and the Home Grounds are to the right of center. Arboretum Road is shown in the area south of the residence, and the Dairy and Truck Farm are to the north. Other farms are shown on the west side of the French Broad River, which divides the estate.

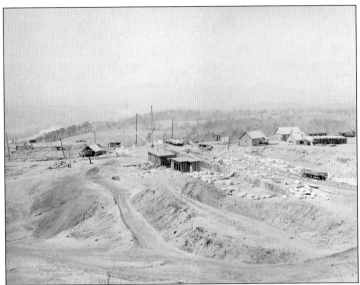

**CONSTRUCTION SCENE ON ESPLANADE, 1891.** The early stages of construction are evident in this photograph of the southwest portion of the Esplanade and house site with the railway and switch tracks. As late as October 1890, estate superintendent Charles McNamee was distressed because of a delayed shipment of curved rails needed to complete the railway in order to commence building the house.

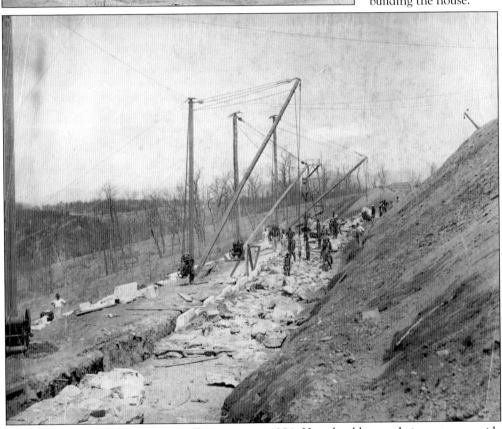

**CONSTRUCTION OF SOUTH TERRACE FOUNDATION, 1891.** Huge boulders are being set to provide a firm base for the west wall of the South Terrace. The adjacent mound of soil most likely came off the Esplanade after the ridge crest was blasted and provided much of the fill needed between the terrace walls. One of Olmsted's two platforms to represent views from the first floor can be seen in the center.

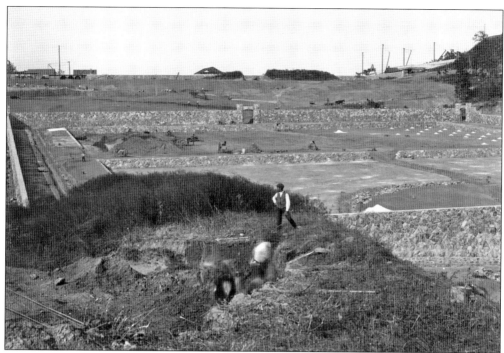

WALLED GARDEN CONSTRUCTION, 1892. Workers are scattered like ants in and around the four-acre garden. Defined by walls and gate arches crafted of local stone, the garden has several terrace levels on the sloping ground. A pair of rails, visible in the lower left of the top view, indicate a small temporary tramway used to transport carts of stone and soil. Civil engineer W. A. Thompson built a tramway in 1893 from the Esplanade to the Bass Pond site for hauling earth to build roads. The white material in the mounds is most likely some type of fertilizer such as nitrate of soda, potash, bone meal, or lime to amend the soil as planting areas are prepared. In the below image, block and tackle rigs facilitate handling of heavy blocks of limestone to construct the steps.

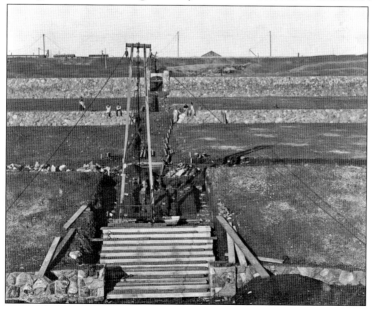

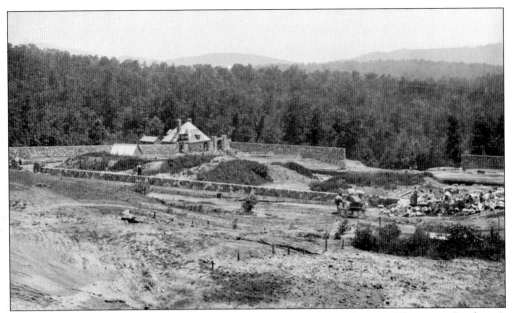

**WALLED GARDEN, 1892, AND GARDENER'S COTTAGE, FEBRUARY 25, 1893.** The stone Gardener's Cottage was one of three cottages constructed during the period of 1891–1893, giving them the distinction of being the first new permanent residences completed on Biltmore Estate. The other two are the Shepherd's Cottage on the west side of the river and Rivercliff on the east. Only the Gardener's and Shepherd's Cottages remain. There was a push to complete the Gardener's Cottage quickly so that the head gardener, Robert Bottomley, could be in residence to help develop the gardens. The same is true for Rivercliff, also known as the Forester's Cottage, for it was the brief residence of Biltmore's first forester, Gifford Pinchot. Olmsted and his wife preferred to stay at Rivercliff if it was available when they were at Biltmore. In the below image, the Wright cabin and outbuildings contrast with the newly constructed Gardener's Cottage.

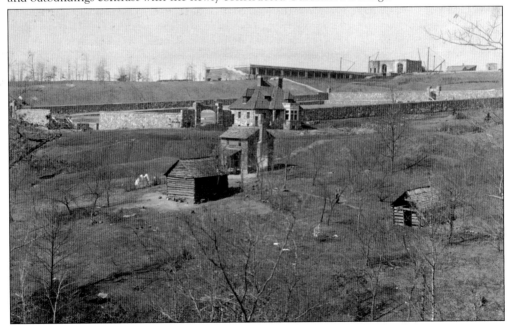

*Three*

# THE APPROACH ROAD

The Approach Road at Biltmore is still recognized today as one of the best examples of Frederick Law Olmsted's designs in the naturalistic and picturesque styles. He considered it an extremely important part of his work and almost immediately plunged into designing its route and figuring out how to use the local topography and existing features in creating the effect he wanted it to have. In a 36-page letter to Vanderbilt in July 1889, Olmsted expressed his initial thoughts for the various divisions of his plan. In reference to preexisting roads on Vanderbilt's land, he observed, "The present roads of the Estate have been laid out as far as practicable on the ridge lands, where they could be made and kept passable at the least cost. Near them the timber has been naturally poorer and has been worse used than elsewhere and the local scenery is monotonous and forlorn. It is in the valleys or gulches between the ridges that the most interesting foliage is to be seen; where there is the greatest moisture and all conditions are the more picturesque."

As for the nearly three-mile approach to the chateau, Olmsted wanted it to have both a visual and an emotional impact on visitors. He tucked the first part of it on a shelf at the base of steep slopes along the bank of the Swannanoa River and then through a narrow valley in which Ram Branch gently flows. Lastly, the path of the road gently ascends to a ridge for its final approach to the residence, having gained 246 feet in elevation. He advised, "I suggest the most striking and pleasing impression of the Estate will be obtained if an approach can be made that shall have throughout a natural and comparatively wild and secluded character; its borders rich with varied forms of vegetation, with incidents growing out of the vicinity of springs and streams and pools, steep banks and rocks, all consistent with the sensation of passing through the remote depths of a natural forest. Such scenery [is] to be maintained with no distant outlook and no open spaces spreading from the road."

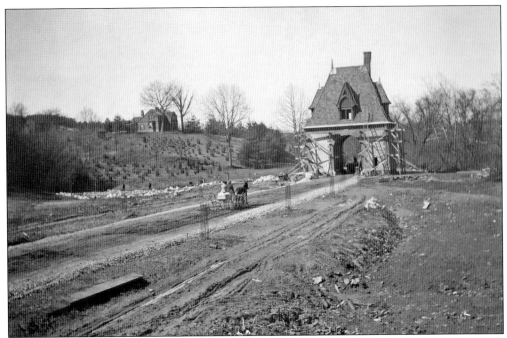

**GATE LODGE UNDER CONSTRUCTION, OCTOBER 15, 1895.** The Gate Lodge was at the main entrance to the estate on the bank of the Swannanoa River. In this view, the residence of a former landowner named Tennent is visible on the left. After renovation, the house was renamed Pincecliff and became the residence of Charles McNamee's assistant Edward J. Harding and later that of engineer Charles E. Waddell and his family. (Courtesy of FLONHS.)

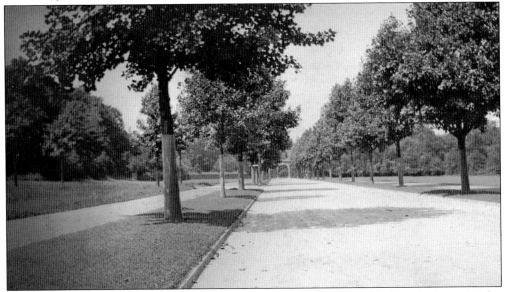

**LODGE STREET, LOOKING WEST, C. 1910.** Richard M. Hunt designed the Gate Lodge, or Lodge Gate, as it is commonly called, between February and June 1895. His last drawing for the structure was dated June 27, a little more than a month before his death. Construction of the building was completed in 1896. Tulip poplars line either side of the drive through the Village Green. (Courtesy of RLUNCA.)

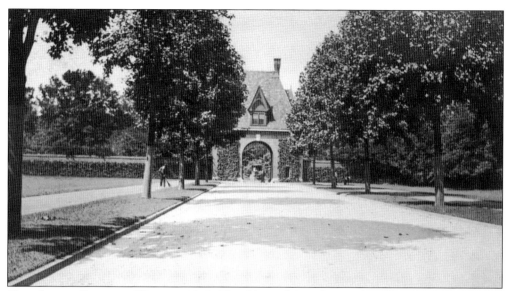

GATE LODGE, LOOKING WEST, C. 1910. The Olmsted firm designed walls on both sides of the building that created the illusion the entire estate was surrounded by them. The wall on the south ended in the side of the hill, and the one on the north next to the river included an enclosed courtyard for privacy. As the gate required an around-the-clock security guard, quarters were provided upstairs. (Courtesy of RLUNCA.)

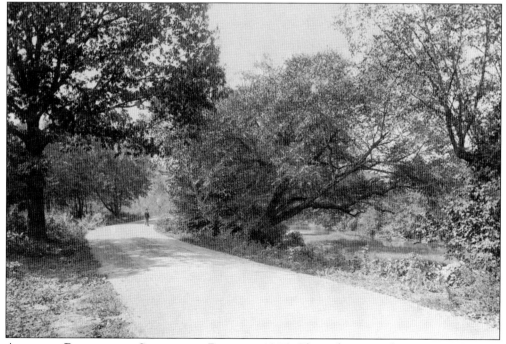

APPROACH ROAD BY THE SWANNANOA RIVER, C. 1895. Olmsted expressed in June 1895, "Most visitors will get their first decided impression of the local scenery while passing over this road." In laying it out and forming its borders, Olmsted's objectives were one, "to present available passages of this scenery to the best advantage," and two, "to secure strong and effective foregrounds for the views over it."

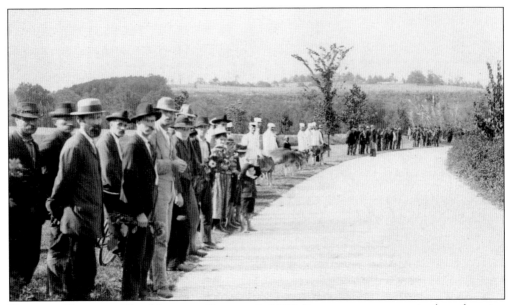

**READY TO GREET THE NEW MISTRESS, OCTOBER 1, 1898.** Estate managers organized a welcoming reception for George Vanderbilt and his new bride, Edith Stuyvesant Dresser Vanderbilt, upon their arrival following their honeymoon. Employees lined up by departments along the Approach Road where it passed by the farm fields near the Swannanoa River. Some employees carried items representative of their work. Dairymen brought Jersey calves, and gardeners carried bouquets of flowers.

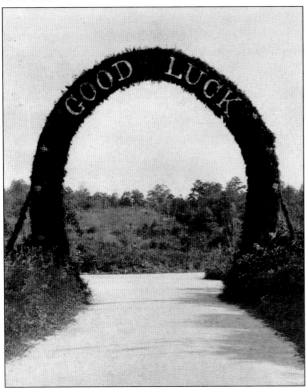

**GOOD LUCK ARCH, OCTOBER 1, 1898.** Employees erected a horseshoe-shaped floral arch with the words "Good Luck" for the newlywed couple to pass through. Forester Carl Schenck planned to have a big fire built on Mount Pisgah that night so it would be conspicuous from Biltmore House. Vanderbilt expressed his appreciation to all employees for their welcome and friendly feelings shown to him and Edith.

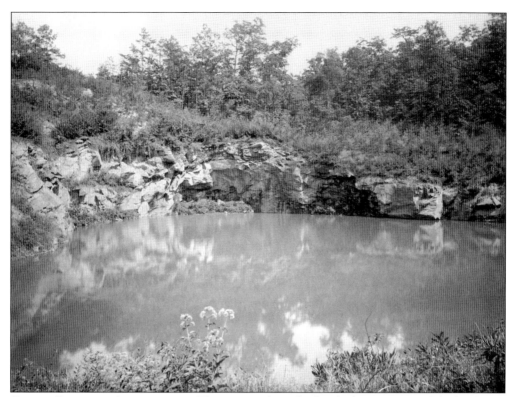

QUARRY POND, 1895 AND C. 1900. These views show the finished appearance of the landscape surrounding the pond that Olmsted had created from the abandoned stone quarry on the lower Approach Road. It is perhaps one of the best illustrations of his naturalistic design in the style of the picturesque and his creative ability for transforming a rough piece of ground into a work of art. Evident in the photograph are the stone walls of the quarry, which Olmsted had blasted to create a natural overhang effect, and the waterfall of Ram Branch entering the pool. True to Olmsted's intent, the surrounding woodland and landscape plantings appear as if they had naturally occurred. The arched stone bridge, under which Ram Branch passes, is one of several on the lower Approach Road. This pond was lost with the construction of Interstate 40 in the 1960s.

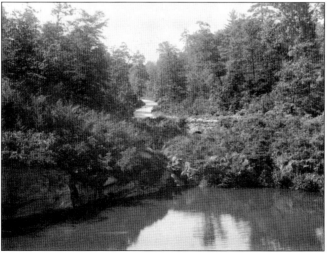

ABOVE THE QUARRY, C. 1894–1895. Olmsted instructed landscape manager James Gall Jr. in February 1890 that before the Approach Road through the valley above the quarry could be precisely laid out, Ram Branch would have to be considerably modified as to its course and be much deepened. He advised that it would have to be Gall's own work even though Olmsted was providing some instructions for it. Further, he should get these well fixed in his mind and use his best judgment, with the understanding that there is nothing in landscape gardening that more often fails of obtaining wholly satisfactory results in respect to naturalness than an undertaking of this kind. Olmsted stated, "I shall presently lay down a few simple general principles for your guidance and give you certain figures of measurement. Within the limits thus fixed you must exercise your artistic taste and judgment."

**PLANTING CREW ON LOWER APPROACH, MARCH 1891.** Olmsted wrote to James Gall again in June 1890, a few months after he had given instructions for the lower Approach Road in February: "Since I left you, I have been meditating more or less every day upon the Ram Branch work . . . I am not sure that I can add to what was then said . . . What has been done between the quarry and the bridge shows that you have caught the spirit of our intention and have managed your force so as to realize it thus far successfully." Above, Gall's crew is planting shrubs. The roller in the roadbed was used to compact the macadam surface. Below, George Vanderbilt is standing in the front row, on the right, with Olmsted and Chauncey Beadle. James Gall Jr. is most likely the man mounted on the horse.

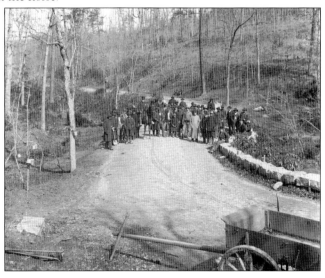

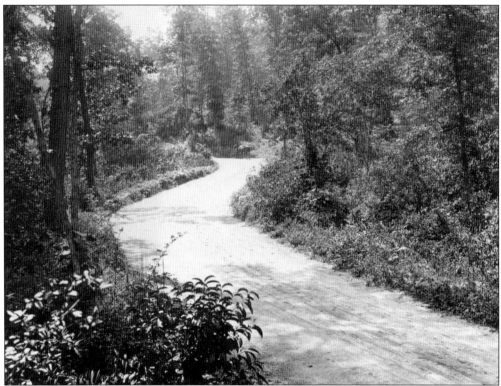

**Densely Planted Vegetation and Pool on Lower Approach, c. 1895.** Olmsted wrote to nurseryman Chauncey Beadle in July 1895: "There is nothing that we are now so immediately anxious about at Biltmore as that these borders should more fully acquire the general aspect originally intended to be given them, and which is broadly suggested by saying that it is an aspect more nearly of sub-tropical luxuriance than would occur spontaneously at Biltmore. The term 'sub-tropical luxuriance' is, of course, used only suggestively. The result desired is to be brought about largely by a profuse use of plants that simply, in certain respects, are calculated to produce a distant, broad, general resemblance to the landscape qualities of sub-tropical scenery . . . that will form compositions more nearly approaching in general landscape character such as are to be seen further south than any that are the result of spontaneous growth near Biltmore."

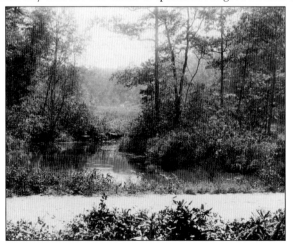

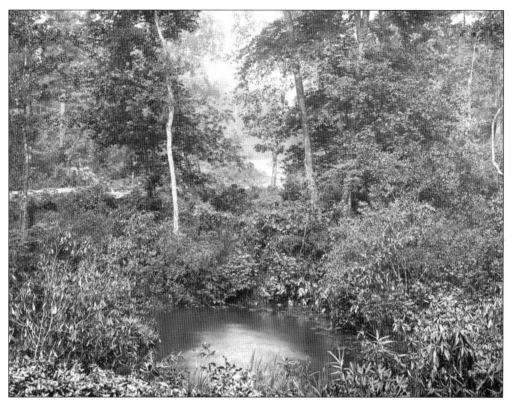

**PLANTINGS ON LOWER APPROACH POOL AT BRIDGE NO. 1 AND RAM BRANCH, C. 1895.** Olmsted specified a profusion of low, smooth-leaved evergreen plants near the edges of the road and down upon the shores of the brook, especially in areas that people would look down upon when passing in carriages along the road. He advised Beadle, "Use every resource and all the ingenuity that you can to refine and enrich the low vegetation, by which the edge of the water in the brook will be covered. Nearly every foot of the water's edge needs to be verdantly covered more perfectly . . . Where the water falls over a flat-faced dam, looking too much like a piece of masonry . . . place [a] stone just under water below the dam where the falling water will strike and rebound from it. This will make foam and sparkle, will confuse the sight and will add to the purling sound."

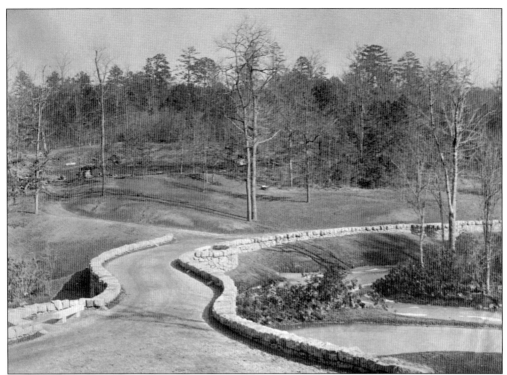

SECOND POND AREA AT BRIDGE NO. 2, 1891 AND C. 1894. In this area, Olmsted planned for the drive to pass directly over the pond. To emphasize the scenic beauty that the plantings and water features would provide, Olmsted incorporated several semicircular balconies with benches to encourage travelers to pause and enjoy the serenity of the setting. For unknown reasons, Vanderbilt questioned the balconies. Olmsted wrote to him in January 1891: "With regard to the balconies on the Approach Road, I hope that you will consent to let them stand until I can ask you to consider the matter with me on the ground. I think it probable that Mr. Gall has not been able to explain the reasons that led us to introduce some of them, especially those suggested by Mr. Smith as a part of the design of the second bridge."

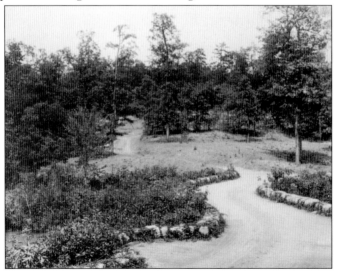

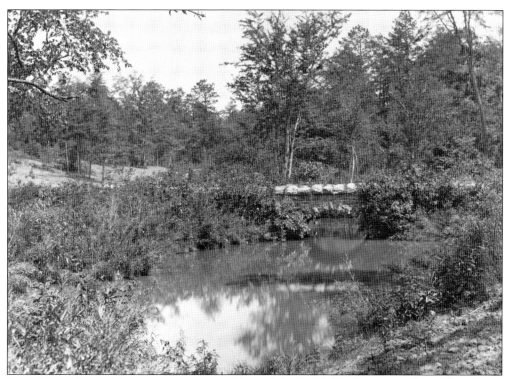

POND NEAR BRIDGE NO. 2, C. 1894–1895. Olmsted discussed the plantings with Beadle: "People coming from New York to Biltmore in the Winter or Spring must be made to feel that they are decidedly nearer the sun. We must aim, then, to gain as much of sub-tropical general character of scenery as we can without a large sacrifice of existing elements of the woodland beauty of the Southern temperate region . . . A richer and more profuse display of bloom early in the Spring will be provided for." It needed to be considered, however, that Vanderbilt and his guests would nearly always miss the best of the bloom and would continue to do so. Olmsted felt that the distant, lasting, and constant semitropical effect of bodies of foliage throughout the year was more critical.

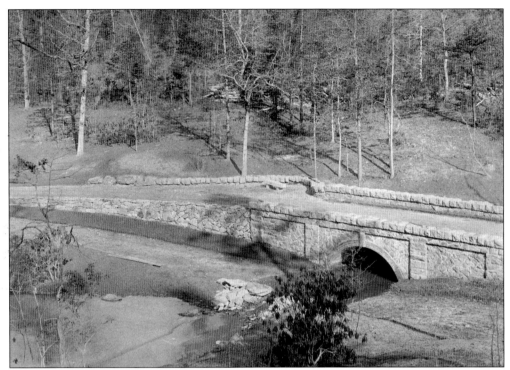

HORSE FORD AT BRIDGE NO. 3, 1890, AND POOL, 1892. At the last and uppermost bridge in the Ram Branch district and just before the ascent to the ridge on the upper Approach Road, Olmsted designed a pull-off as a wayside stop for horses and mules to rest and get a cool drink of water. The main pond (not visible) was on the upstream side of the bridge. It could be viewed from the balcony or from a horse or carriage on the bridge. A smaller stone dam, on the downstream side of the bridge, formed a shallow pool over which the ford crossed. A ground-level perspective of the dam and pool is seen in the bottom photograph. Native rhododendrons and mountain laurel complement the setting.

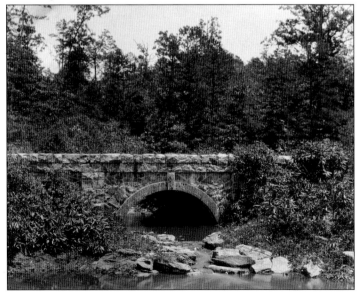

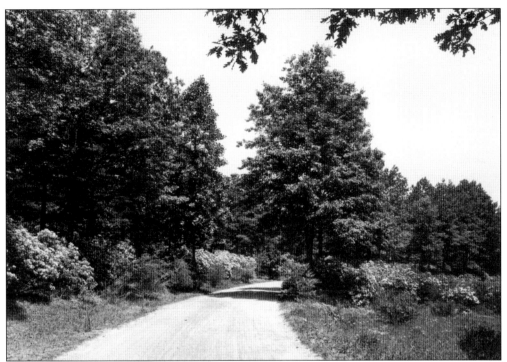

**PLANTINGS ON LOWER APPROACH, 1930.** By 1894, the landscape department had reached the goal of collecting, propagating, and planting thousands of native rhododendrons, kalmias, and leucothoe on the Approach Road. Of these, many were the treelike *Rhododendron maximum*, known as rosebay or great laurel, that typically flowers in summer from the last part of June through early July. In a letter found in the Olmsted Associates Records at the Library of Congress from George Vanderbilt to Frederick Law Olmsted on July 7, 1895, Vanderbilt expresses his obvious approval of Olmsted's and Beadle's work. "The rhododendrons are now in bloom and the lower approach with these and other blossoms is a vale of delights. I only wish everyone could see it at this season for the first time."

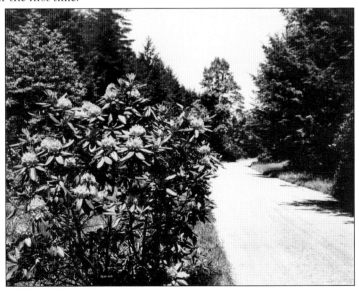

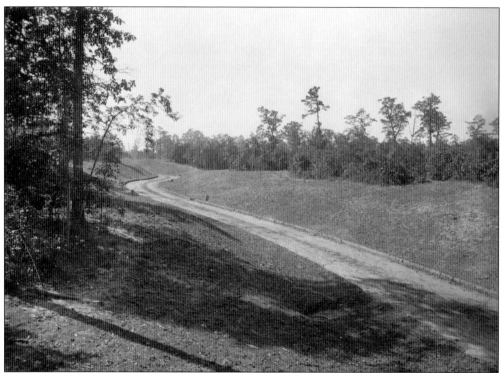

**MIDDLE APPROACH GRADING, OCTOBER 1, 1892.** Early in the project in November 1889, Olmsted instructed his civil engineer W.A. Thompson concerning the Approach Road. "Assume that the wheelway, exclusive of gutters, is to be 18 ft. broad; that there is to be no curve in its course of a less radius than 35 feet, and that its grade is to be nowhere steeper than 1 in 20. In determining the exact lines of the road, particularly where it is to be built as a shelf thrown out from a hillside, allow space for gutters and for graceful borders, etc., as follows: Wherever the surface of the adjoining ground is to be higher than that of the road there is to be on that side a paved gutter ordinarily from 2 to 3 feet wide, outside the 18 ft. wheelway."

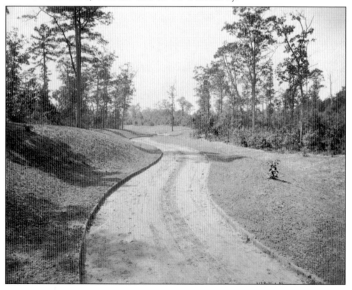

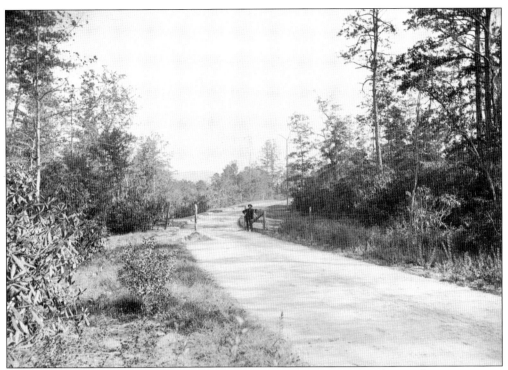

MIDDLE APPROACH, OCTOBER 1, 1892, AND PLANTINGS, C. 1905. In a letter of instructions to Charles McNamee on November 30, 1893, Olmsted writes that Bottomley, the head gardener, is to be employed, under Gall's orders, in improving the planting all along the Approach Road, particularly the "dove-tailing together of groups." "In the upper part, a larger number of brambles, briers, chinquapins and other native shrubs need to be introduced to better disguise the fact that the plantations are artificial, and to make them appear more nearly spontaneous and wild. Mr. Gall will see to it that Mr. Bottomley is not timid in this respect and that he has a sufficient supply of native plants for the purpose stated." The below view shows the density and variety of vegetation planted to achieve the layered effect of picturesque landscape specified by Olmsted.

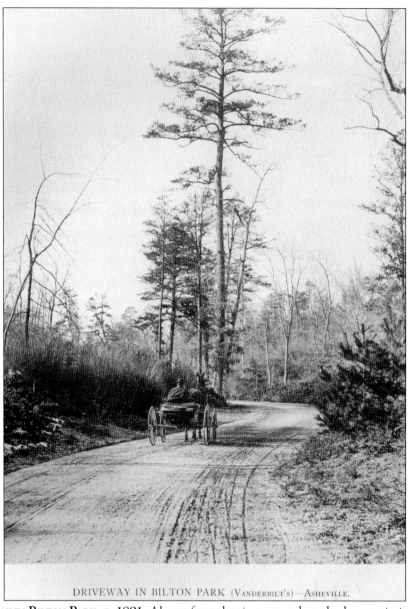

DRIVEWAY IN BILTON PARK (Vanderbilt's)—Asheville.

**Driveway in Bilton Park, c. 1891.** Almost from the time ground was broken, curiosity-seekers could obtain permits to ride on designated estate roads on pass days only. By 1903, three forms of tickets were issued at values of 50¢, 25¢, and 10¢ depending on type of conveyance for Tuesdays, Thursdays, and Saturdays. Prior to George Vanderbilt's arrival, the community south of Asheville had been known as Best by the post office and also Asheville Junction by the railroad company. Vanderbilt's first choice for naming the estate was "Bilton Forest" and his residence as "Bilton House." In February 1890, the superintendent of the railroad agreed to designate Asheville Junction as Bilton on timetables. However, the postmaster general in Washington denied the request to change the post office name from Best to Bilton due to the similarity to the post office names of Bolton and Boilston elsewhere in North Carolina. Soon afterwards, Vanderbilt decided to change the name to Biltmore, which he liked better, and requested this name be adopted. (Courtesy of the North Carolina Collection, Pack Memorial Library, Asheville.)

**UPPER APPROACH, 1930.** It was Olmsted's design intent that the Approach Road ascend gently for nearly three miles to the house, passing through a natural forest of white pines, hemlocks, tulip trees, oaks, maples, and dogwoods. Foreground plantings of native rhododendrons, mountain laurels, hollies, and many other varieties of shrubs provide a year-round sea of foliage. Following first a small stream meandering through a pleasant ravine with pools and small grassy meadows, then along a thickly wooded ridge, the road provides a constantly but subtly changing scene around every turn: "All consistent with the sensation of passing through the remote depths of a natural forest. Such scenery [is] to be maintained with no distant outlook or open spaces spreading from the road and with nothing showing obvious art."

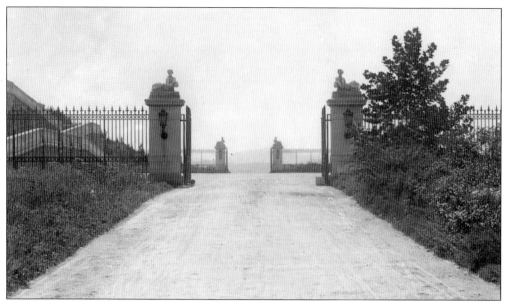

ARRIVAL AT THE ESPLANADE, C. 1900 AND 1902. "Until the visitor passes with an abrupt transition into the enclosure of the trim, level, open, airy, spacious, thoroughly artificial court, and the Residence, with its orderly dependencies, breaks suddenly and fully upon him. Then, after passing through the building, the grandeur of the mountains, the beauty of the valley, the openness and tranquility of the park would be most effectively and even surprisingly presented, from the windows, balconies and terrace." Olmsted's solution for dealing with the contrast of merging from the naturalistic wooded landscape of the Approach Road into the "trim, level, open, airy, spacious, thoroughly artificial court" was by creating "an abrupt transition" for a breathtaking experience. (Below, photograph by William Henry Jackson, courtesy of the Library of Congress, Prints and Photographs Division, Detroit Publishing Company Collection.)

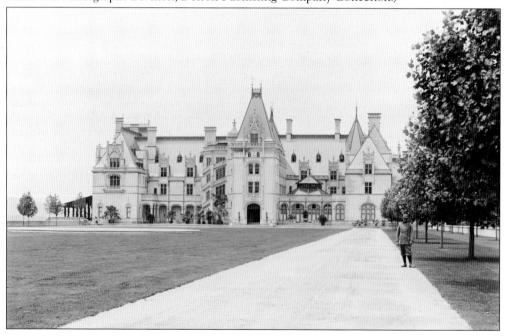

# *Four*

# THE HOME GROUNDS AND GARDENS

In many respects, the Home Grounds as they were planned and developed are the centerpiece—the heart and soul of the estate's landscape. The Home Grounds, as the term suggests, surround or radiate from the residence. They are the place where the Vanderbilts welcomed family and friends, where their guests recreated and relaxed. There is no clear delineation of how far the Home Grounds extend beyond the house except what is shown on a couple of early preliminary maps. They are generally confined to the area of more formal spaces that are kept closely mowed and trimmed, like the Esplanade and Vista, the terraces, and the gardens down to the Conservatory. Even during their creation, Olmsted observed that the gardens and grounds were not simply just the private grounds of George Vanderbilt but were already drawing much attention by the public and attracting lots of curious visitors to the estate. Olmsted's enthusiasm for the project was due in part to his already cordial relationship with Vanderbilt but more so because he saw that many influential people were visiting Biltmore and paying attention to what was developing. Very early in the project, Olmsted stated, "This is to be a private work of very rare public interest in many ways . . . I feel a good deal of ardor about it, and it is increased by the obviously exacting yet frank, trustful, confiding and cordially friendly disposition toward all of us which Mr. Vanderbilt manifests." In the spring of 1894, Olmsted proclaimed to his partners, "The public is more and more making a resort of the place and I more & more feel that is the most permanently important public work and the most critical with reference to the future of our profession of all that we have." Those words are particularly significant given that most of Olmsted's career was devoted to public parks and the grounds of other public spaces.

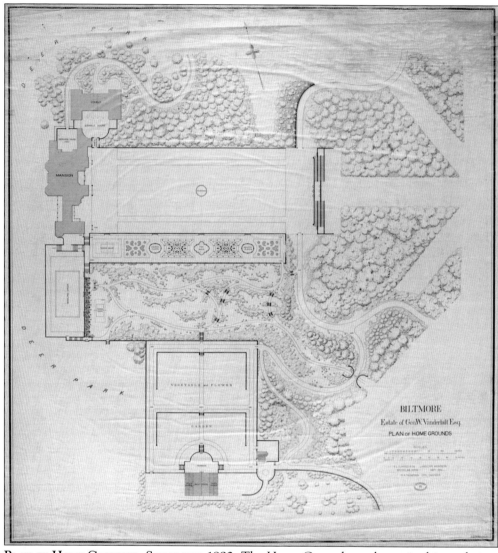

**PLAN OF HOME GROUNDS, SEPTEMBER 1892.** The Home Grounds, as shown in this rendering, include the Esplanade; Rampe Douce (meaning "pleasant incline"); Vista with angled vistas at the summit (one toward Asheville to the northwest and one toward Mount Pisgah to the southwest); the Garden Terrace (with central fish basin and two pools for aquatic plants between four parterres and tennis court); the South Terrace with Bowling Green; Shrub Garden with tennis court near Pergola; Vegetable and Flower Garden; palm house and greenhouses; and the Gardener's Cottage. On the periphery is the brick arch that leads to the Spring Garden on the east, and a small portion of the Deer Park is shown on the west side of the house. The only gardens with labels are the Bowling Green and the Vegetable and Flower Garden. Other surviving drawings showing the general area, or portions of, are dated from January 1889 to January 1893.

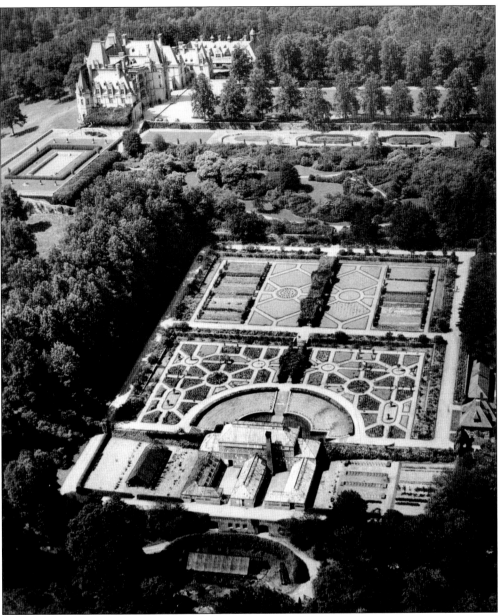

**AERIAL VIEW OF BILTMORE HOUSE AND HOME GROUNDS, C. 1950.** This aerial view of Biltmore House and the formal gardens is looking north. It encompasses a large portion of Olmsted's designed Home Grounds, and includes the Esplanade; the Garden Terrace, or Italian Garden; the South Terrace; the Ramble, or Shrub Garden; the Walled Garden (originally the Vegetable and Flower Garden); and the Conservatory. With the exception of the Vista and the easternmost portion of the Shrub Garden not being in the view, the photograph coincides very closely with Olmsted's "Plan of the Home Grounds" from September 1892. The detailed layout of the Walled Garden's pattern beds and borders are clearly visible, as are the two sections of the vine-clad arbor. The Conservatory and greenhouse complex with various dependencies like the gardener's work yard, cold frames, and lath houses are at the bottom of the photograph. To the north of the Walled Garden, portions of the Shrub and Italian Gardens and the Esplanade can be seen.

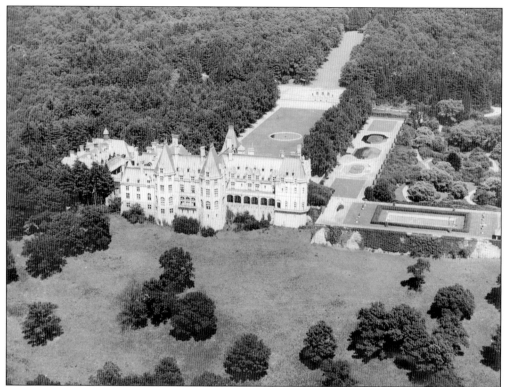

**HOUSE AND GROUNDS FROM ABOVE, C. 1950.** This aerial view of the west facade of Biltmore House and grounds is looking almost due east from a point above the Deer Park, west of Biltmore House. The photograph documents a substantial portion of the Home Grounds, including the Esplanade and Vista; the Garden Terrace, or Italian Garden; the Ramble, or Shrub Garden; the South Terrace; and the relative landscapes in a mature stage of growth.

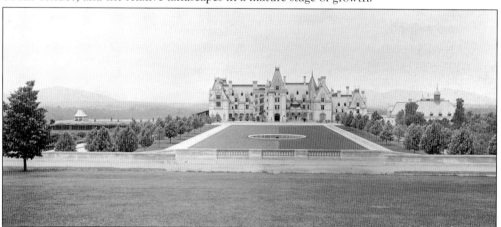

**BILTMORE HOUSE AND ESPLANADE, 1902.** Hunt and Olmsted collaborated on the plan for the chateau's forecourt, known as the Esplanade. After months of discussion, Olmsted apparently conceded his suggestion for an informal approach with curvilinear drive to Hunt's plan for a formal and level lawn with straight drives and allées on either side. (Photograph by William Henry Jackson, courtesy of the Library of Congress, Prints and Photographs Division, Detroit Publishing Company Collection.)

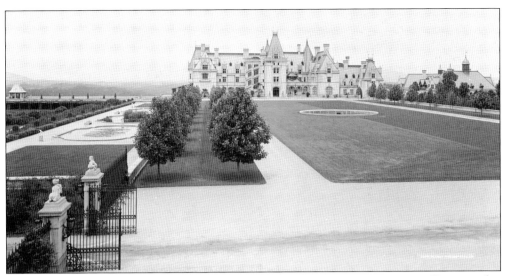

TULIP POPLAR ALLÉES, 1902, AND NICHE IN RAMPE DOUCE, SEPTEMBER 1900. Hunt sent his plan for the Esplanade with written notes to Olmsted in December 1889. Hunt wrote, "I deem it wise to keep Esplanade virtually level in order to secure a good vista from both ends . . . Lines in axis of two end wings will run through middle of broad walk in grass planted with trees . . . Linden trees I think—same as used in French Chateaux, thus forming a shadowed *berceau* or shady walk with *tapis vert*. The drives coming up inner sides of these alleys . . . Plaza at either end 100 feet wide—no trees." Olmsted apparently accepted, as Hunt seemed set on his plan. Olmsted's successive drawings incorporated Hunt's plan. (Above, photograph by William Henry Jackson, courtesy of the Library of Congress, Prints and Photographs Division, Detroit Publishing Company Collection; below, courtesy of FLONHS.)

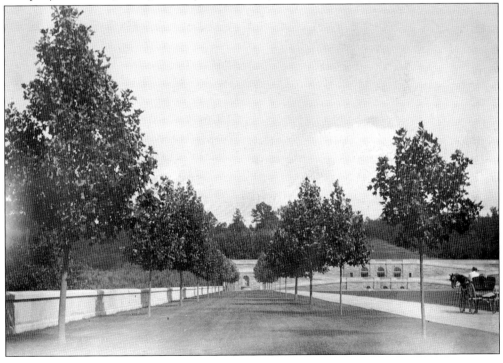

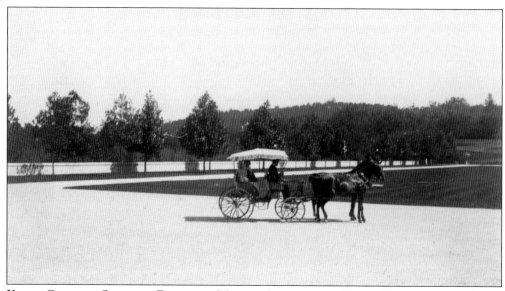

**YOUNG CORNELIA OUT FOR A DRIVE AND MARION OLMSTED NEAR RAMPE DOUCE, C. 1901.** In the above photograph taken by Edith Vanderbilt on October 2, 1901, one year-old Cornelia Vanderbilt and unidentified woman, probably her nanny, appear set to head out for a carriage drive around the estate. Below, Olmsted's daughter Marion pauses near the Rampe Douce while exploring the estate by bicycle. Marion initially came to Biltmore with her father and mother and enjoyed hiking and camping expeditions with the Vanderbilts in Pisgah Forest. Between 1901 and 1903, Marion sometimes rented a cottage on the estate for a few months. In November 1901, Marion wrote to Charles McNamee that her horse and her bicycle had not yet been sent to her and asks for repairs to her cottage. In June 1902, forester Carl Schenck refused to give Marion Olmsted a pass to fish in the river unless George Vanderbilt personally approved it.

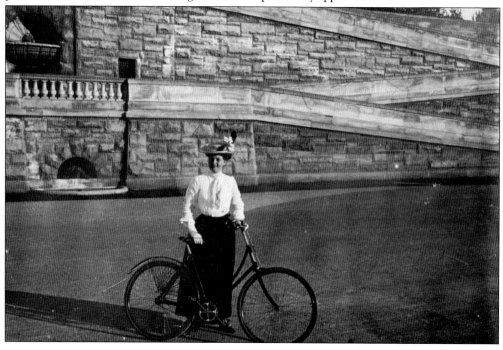

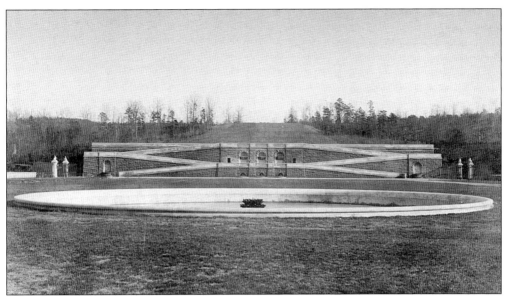

VIEW OF RAMPE DOUCE AND VISTA FROM ESPLANADE, 1896 AND 1900. The French estate Vaux-le-Vicomte may have inspired the design of the Rampe Douce and Vista at Biltmore. In the above 1896 photograph, it appears that no structure has yet been built on the Vista. In June 1894, James Gall reported that the columns originally intended for the Pergola (below South Terrace), including two broken ones, had been sent to top of the Vista. Engineer J.L. Howard reported on May 25, 1895, that he had mapped the pavilion at the top of the Vista. The photograph was apparently taken earlier than the date indicates. In the image below, the pavilion is clearly in place by 1900, and it appears that small vines are on the columns. (Above, photograph by T.H. Lindsey, courtesy of Shelburne Farms, Shelburne, Vermont.)

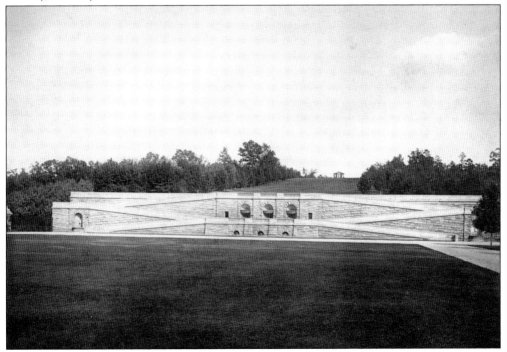

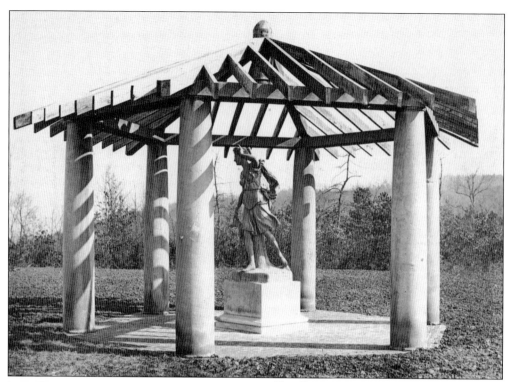

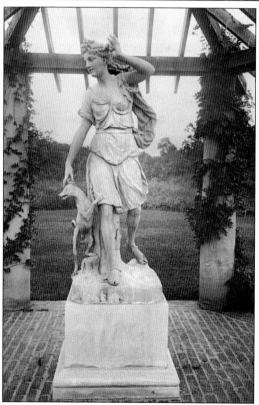

THE DIANA PAVILION, 1900 AND C. 1902. In the above photograph, first published in *Biltmore Photo-Gravures* (1900) by H. Taylor Rogers, bookseller and stationer of Asheville, the pavilion or pergola has been built, but the vines have not yet been planted to grow on the columns. The date of the *Diana* sculpture's installation has not been documented. Chauncey Beadle and Olmsted Brothers continued developing plans for the summit of the Vista through at least 1901. Beadle received grading and planting plans in December 1898 for shrub plantings around the edges of the adjacent woodland. In April 1900, Beadle instructed head gardener Robert Bottomley to plant wisteria at the base of the pillars of the belvedere, or teahouse, at the top of the Vista, as Vanderbilt was anxious to have the structure covered.

VIEW SHOWING PERGOLA ON VISTA, SEPTEMBER 1900 AND 1906. Chauncey Beadle reported to Edward Harding in the estate superintendent's office on October 5, 1900, about George Vanderbilt's approval of a parapet and balustrade at the top of the Vista. A temporary model was erected to show the effect of stonework. On November 26, McNamee advised that the Vista parapet would not be constructed that year. It has not been determined if the parapet shown in the above image is temporary or real. Beadle reported to Vanderbilt in early May 1901 that the planting at the top of the Vista was only partially done, as he had been waiting on a plan from Olmsted Brothers. Below, the wisteria had covered the Diana pavilion thoroughly by 1906. (Above, courtesy of FLONHS.)

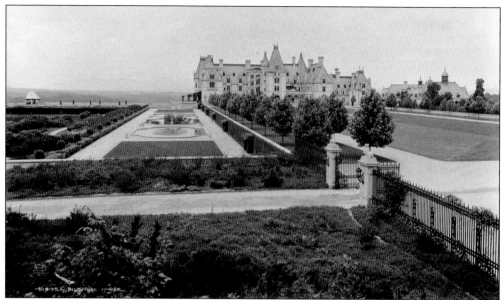

GARDEN TERRACE AND RAMBLE, 1902, AND LIBRARY TERRACE, C. 1896. In this view looking across the Garden Terrace, the Library and South Terraces can be seen on the left, or south, end of Biltmore House. Below, the metal framework with canvas duck covering extended the seasonal use of the Library Terrace. The top cover sections could be rolled up and down as needed for shade or protection from rain. Horizontal rods were fitted with panels that could be opened or closed in sections and secured to tie downs on the vertical posts in windy conditions. The wedge-shaped panels on the east and west ends had a decorative edge and remained stationary. Side panels are shown bunched and tied around the columns. (Above, photograph by William Henry Jackson, courtesy of the Library of Congress, Prints and Photographs Division, Detroit Publishing Company Collection.)

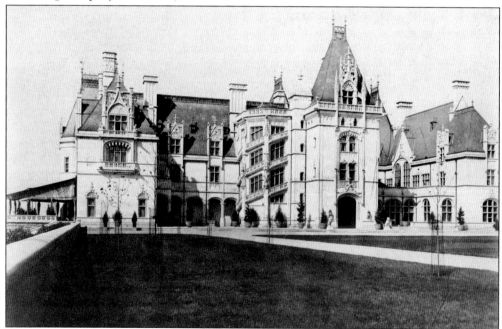

**LIBRARY TERRACE, JUNE 1903.** Chauncey Beadle ordered 16 *Actinidia* vines, or ornamental kiwi, for planting on the Library Terrace. The wooden planters were designed by the Hunt firm with hinged side doors that made it easier to change out plants in tubs. Another vine, Virginia creeper, is growing in the planters in the center and corner. One of the Vanderbilts' Saint Bernards has found a cool place to take a nap. (Photograph by Frederick Law Olmsted Jr., courtesy of FLONHS.)

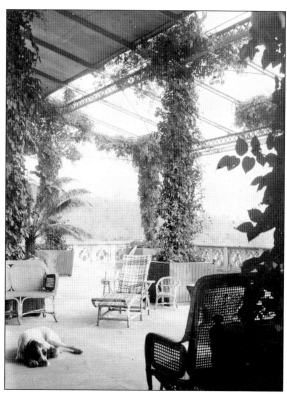

**EDITH AND CORNELIA VANDERBILT AT LIBRARY TERRACE, C. 1910.** Edith Vanderbilt and her daughter, Cornelia, are posing in riding attire as one of the family's Saint Bernards sits patiently. Beadle requested permission to purchase canvas to replace the awning in April 1910, about the time of this photograph. In April 1923, the terrace was repaved, with sections around the columns or posts left unpaved so that Virginia creepers and fox grapes could be planted in prepared soil.

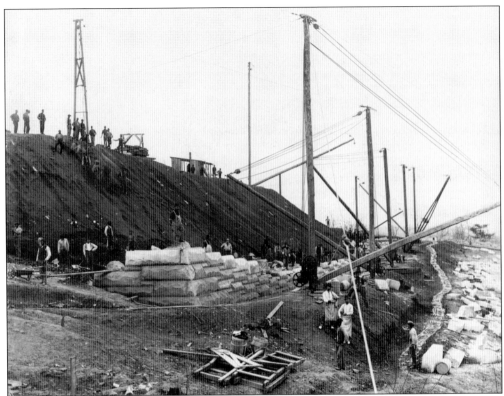

**CONSTRUCTION OF SOUTH TERRACE FOUNDATION, 1891, AND WEST FACADE, C. 1895.** Construction of the terrace was a massive project. The concept for such a terrace was suggested to Hunt by Olmsted, as it would provide a place for enjoying views of the park below and the distant mountains while getting some fresh air. He suggested that a terrace "thrown out southwardly from the house" would provide a place "for a short stroll or a prominade [sic] which shall be as it were a part of the house. . . from which while walking the great view westward . . . the valley and the distance with its far-away snow-capped hills . . . can be enjoyed." Further, its high walls would help to buffer the winds sweeping over the ridge from the north and west to protect the garden on the east side of it.

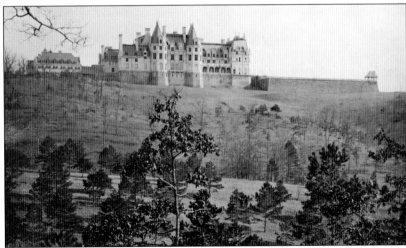

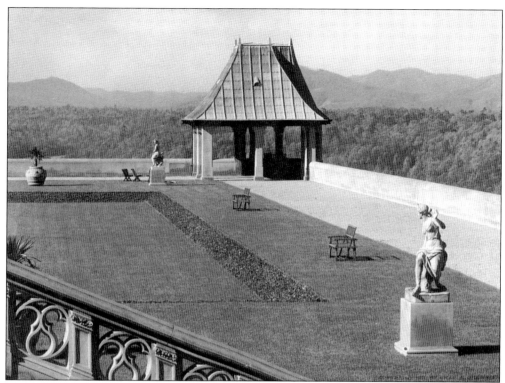

**BOWLING GREEN AND TEAHOUSE ON SOUTH TERRACE, 1900 AND SEPTEMBER 1901.** Olmsted developed more than one concept for the South Terrace before deciding on the sunken Bowling Green. He intended for the terrace to be "a great out of door general apartment" that would provide a place for relaxing and enjoying sunsets or doing a little lawn bowling. He was insistent that a structure such as the teahouse be constructed on the southwest end to serve as a destination for a stroll. The beveled slopes around the sunken bowling lawn were planted with English ivy that was kept clipped. The space was furnished with seats, urns, and jardinières for seasonal plants. (Below, photograph by Frederick Law Olmsted Jr., courtesy of FLONHS.)

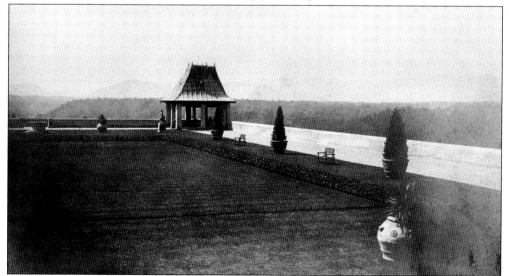

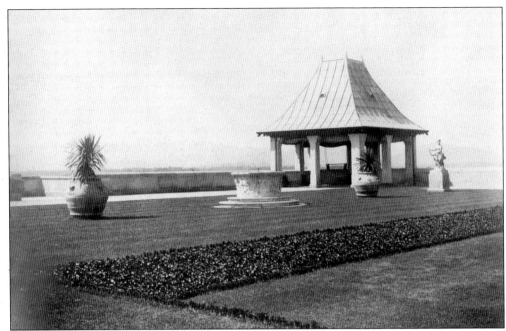

**Teahouse with Swing, September 1901, and Bowling Green, c. 1905.** Olmsted's insistence on a sheltered spot on the southwest end of the terrace resulted in this peaceful retreat. In the spring of 1915, Beadle corresponded with a supplier regarding ordering 11 shades "for a Tea House with stone columns" on Biltmore Estate and discussed side rings to keep the curtains in place, "without such fastenings the wind (it is an extremely exposed situation) would cause the curtains to be blown from their correct position." He asked them to submit an estimate of cost. A pair of matching, canopy-covered seats is seen on either side of the fountain next to the foundation wall of the Library Terrace steps. Ivy is covering the wall of the staircase and around the fountain. (Above, photograph by Frederick Law Olmsted Jr., courtesy of FLONHS.)

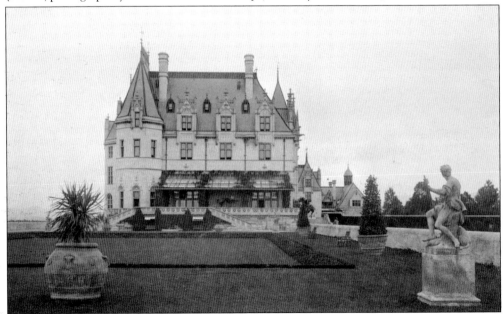

**SWIMMING POOL ON SOUTH TERRACE, 1930.** At George Vanderbilt's request, Chauncey Beadle installed a double row of boxwoods as an edging on the slope surrounding the Bowling Green in March 1901. Beadle wrote to Edith in late March 1920 discussing two different plans for a swimming pool that she wanted designed to fit the space within the lower level of the Bowling Green. The larger one, 58.5 by 139 feet, would cost roughly $7,000; the smaller one, 40 by 120 feet, would be about $4,000. He admitted both would be a larger and costlier undertaking than he expected and that he needed her approval to proceed. Engineer Charles Waddell designed the pool that was constructed and used by family and guests through the next three or four decades. The pool and boxwoods were removed in 1992 and the space used for concerts and other events.

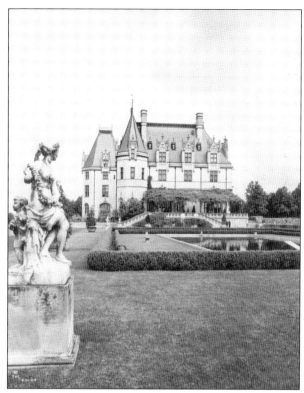

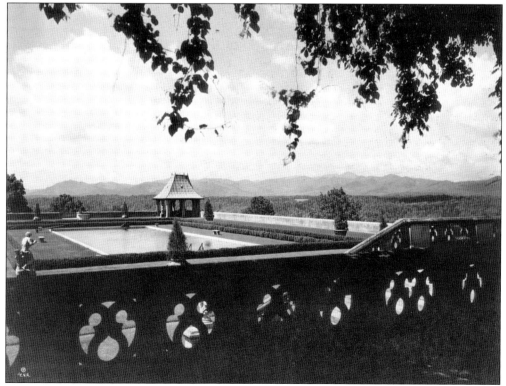

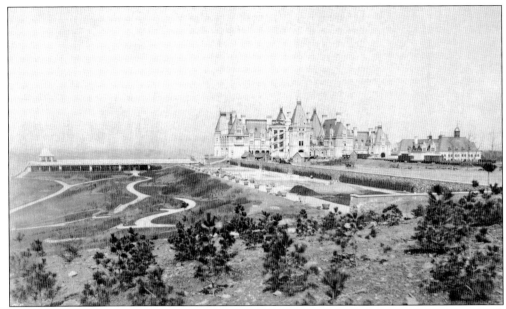

GARDEN TERRACE UNDER CONSTRUCTION, MARCH 26, 1895, AND ESPLANADE, SUMMER 1895. The levels and design for the Esplanade had to be agreed on by Olmsted, Hunt, and Vanderbilt before the lines of the Garden Terrace could be determined. In March 1895, the landscape department reported that a great deal had been done toward reclaiming the Esplanade from its derricks, temporary buildings, tracks, sheds, and other accumulated structures. The work of excavating and constructing the center fountain was underway, and preparation of the ground for planting and seeding would be done as soon as a sufficient quantity of rich surface soil, stripped from the streets of Biltmore Village, was added to a depth of 18 inches. An extra locomotive was hired to expedite hauling of the soil. The driveway on the north side of the Esplanade had been graded and macadamized, and the railroad track had been laid on the driveway. (Below, courtesy of FLONHS.)

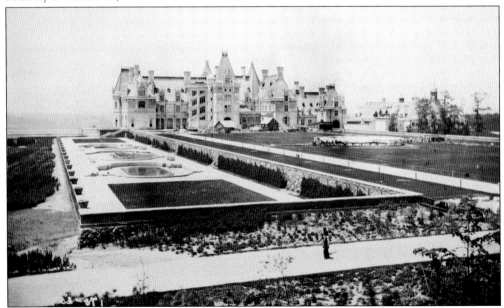

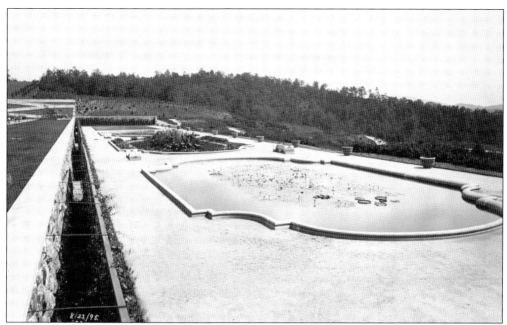

**VIEW OF GARDEN TERRACE, OR ITALIAN GARDEN, AUGUST 23, 1895, AND C. 1905.** Both views are looking east. Olmsted developed several designs for the formal space that extended more than 600 feet, almost the entire length of the Esplanade, before one was selected. An early design proposal called for three geometrically shaped basins, one for fish and two for aquatic plants. These water features were planned to set between formal parterres designed with intricate patterns of plantings, but the parterres did not make the final cut. Lawn-tennis courts on either end also functioned for croquet. A wire trellis on the retaining wall supported vines and kept them off the wall. Below, the sculpture *Dancing Lesson* is in the foreground, and croquet wickets are set up in the grass just behind the sculpture.

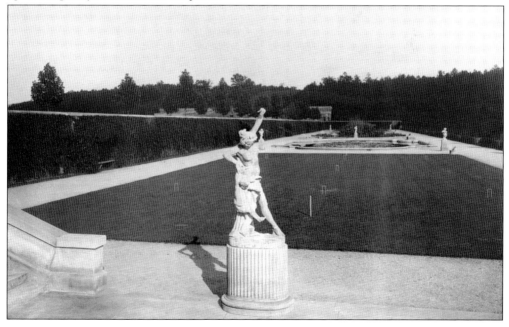

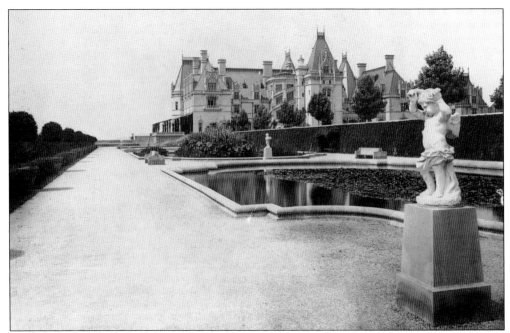

**GARDEN TERRACE, OR ITALIAN GARDEN, C. 1900.** The central pool contains beds with different levels of water and planting depths to meet the needs of specific aquatic plants and others that thrive in high moisture environments. Hybrid water lilies, lotus, iris, pickerel rush, and others bloom in succession beginning in late spring to early fall. An American holly hedge with large terra-cotta urns for specimen trees at intervals separated the space from the Ramble, or Shrub Garden, below. Exactly when and how this space came to be called the Italian Garden is a mystery, since the design is basically French in style. Perhaps the terrace statuary and the large terra-cotta urns used for tree planters purchased in Italy influenced the naming of the space.

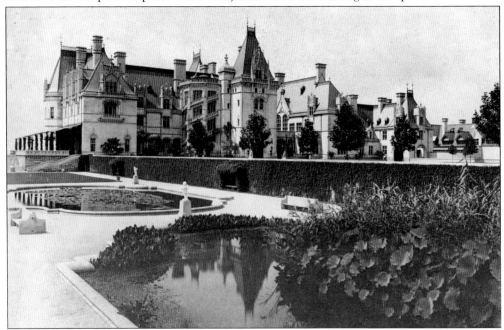

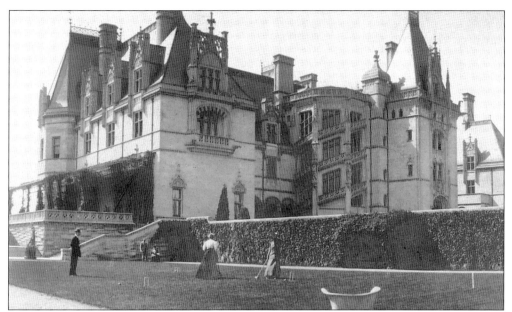

CROQUET IN THE ITALIAN GARDEN, MAY 1906. Olmsted's designs incorporated opportunities for relaxation and recreation in the gardens and other areas. Houseguests could take advantage of a game of croquet, tennis, or lawn bowling without venturing too far from the house. The southern orientation of the terrace in the lee provided by the stone wall on the north side and the South Terrace on the west created a sheltered space.

VIEW OF THE RAMBLE FROM SOUTH TERRACE, C. 1895. On March 2, 1889, Olmsted wrote to Hunt, "A place out-of-doors is wanted which attractive at all times in a different way from the terrace, will be available for a ramble even during a northwester and in the depth of the winter. This would be a glen-like place with narrow winding paths between steepish slopes with evergreen shrubbery, in the lee of the house on the southeast."

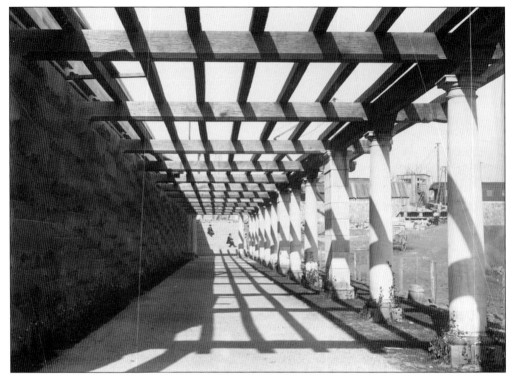

**VIEW THROUGH PERGOLA, 1892 AND 1896.** The Pergola, with massive 24-foot-thick rafters that are a resting on limestone columns, extends for most of the length of the east side of the South Terrace. As seen in the above photograph, Olmsted had the planting pits prepared and vines planted in 1892 to show some early progress in the gardens. Three different vines—Japanese wisteria, trumpet creeper, and English ivy—were planted for year-round effect. Apparently, the Pergola timbers were initially made of pine or other less-durable wood, because in June 1901, head carpenter J.C. Lipe examined the Pergola, found it decayed, and recommended rebuilding it. George Vanderbilt wanted to replace it with California redwood, but considering the cost after securing bids, estate superintendent Charles McNamee consulted with Beadle for his advice.

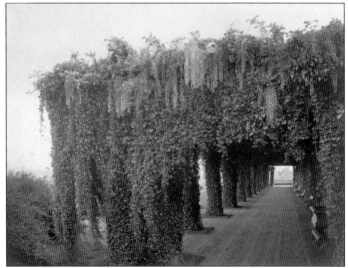

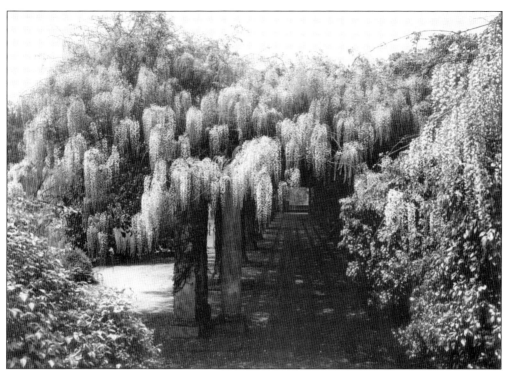

VIEW THROUGH PERGOLA, 1930, AND SUMMERTIME EVENT, JULY 12, 1922. Mostly hidden by the wisteria but barely visible through the columns is a fence that surrounded Edith Vanderbilt's tennis court. Olmsted had specified a lawn-tennis court with a north-south orientation for the same area on the west end of the Shrub Garden near the Pergola. Beadle received information and quotes for "erecting an enclosure around a tennis court located at Biltmore" in June 1914. In the image showing an event at Biltmore House in July 1922, the top of the tennis court fence can be seen beyond and over the line of cars closest to the house. An avid tennis player, Edith received a letter from the Asheville Country Club in June 1915 informing her that the tennis courts she donated were finished and asking for her input on placing a sign reading "Vanderbilt Courts" over the entrance.

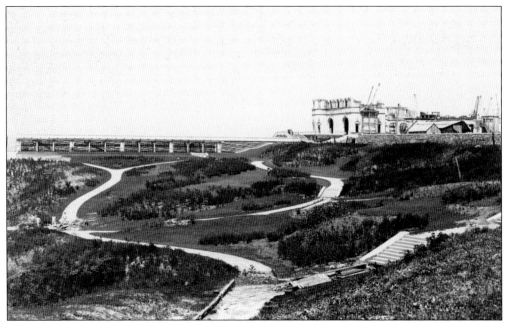

VIEW OF THE RAMBLE, OR SHRUB GARDEN, C. 1893 AND SPRING 1895. The Ramble, or Shrub Garden, covers approximately four acres, and the Olmsted plan lists more than 500 varieties of flowering shrubs, trees, and hardy perennials for the garden. Much of it had been planted from Biltmore nursery stock by the time the walls of Biltmore House had reached the second floor. By the end of 1893, the nursery reported that the department had received 209,925 plants, propagated another 2,935,615, collected locally another 366,527, and permanently planted on the estate 2,870,628. Olmsted specified that the Ramble, as he sometimes called it, "is to have a considerable amount of turf between the walk and the plantations . . . The main bodies of planting will be made up of large shrubs near the upper parts which can be looked over by anyone standing on the terrace." (Below, courtesy of FLONHS.)

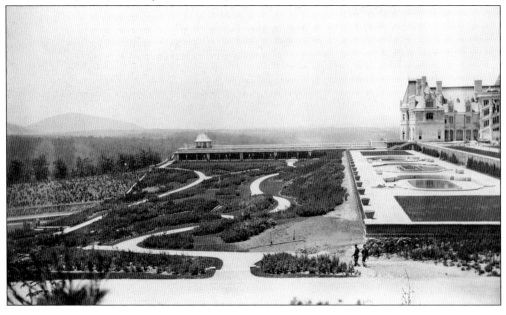

VIEW OF SHRUB GARDEN FROM PERGOLA, APRIL 1907, AND CEDRIC IN GARDEN, FEBRUARY 1900. The main entrance into the Shrub Garden from Biltmore House is through the Pergola below the South Terrace and Italian garden. The upper path parallels the slope below the Garden Terrace and connects with the road leading from the south gates of the Esplanade. The lower path leads to the Walled Garden and Spring Garden. Olmsted intended that farther down the slope the Judas trees, thorns (hawthorns), and flowering dogwoods would predominate in the center of the masses. The masses were to be made up of more garden-like shrubs and small trees. Flowering cherries, flowering apples, and others would be used. Below, one of George Vanderbilt's Saint Bernards is inspecting the beds of shrubbery. (Above, photograph by Frederick Law Olmsted Jr.; below, photograph by John C. Olmsted; both, courtesy of FLONHS.)

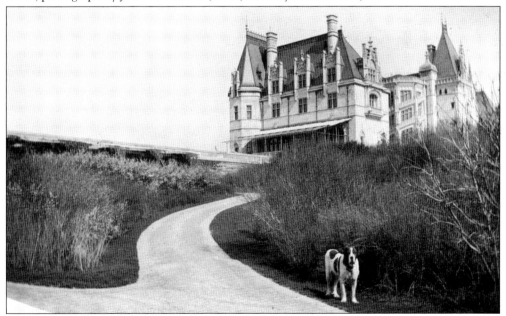

**BRICK ARCH CONNECTING SHRUB AND SPRING GARDENS, SEPTEMBER 1900.** This photograph taken by Frederick Law Olmsted Jr. shows the planting south of the arch in a view looking from the Spring Garden into the Shrub Garden. The planting consists of *Juniperus sabina, Ilex crenata, Yucca, Berberis* (*Mahonia*) *japonica, Hypericum calycinum, Hedera helix,* and other shrubs. The arch separated pedestrians on the garden path from traffic on the carriage road above. (Photograph by Frederick Law Olmsted Jr., courtesy of FLONHS.)

**IN THE SHRUB GARDEN, APRIL 1907.** Olmsted's intent was to have a considerable amount of turf between the walk and the plantations. In this turf, he wanted a variety of individual trees like the river birch on the right and shrubs breaking out from the main bodies of the planting. In the lower part of the garden, more trees were to be used. (Photograph by Frederick Law Olmsted Jr., courtesy of FLONHS.)

CORNELIA VANDERBILT AND JOHN NICHOLAS BROWN, 1905. Five-year old Cornelia Vanderbilt (left) and her cousin John Nicholas Brown II are gardening in the Shrub Garden. John's father, John Nicholas Brown I, married Edith Vanderbilt's sister Natalie Dresser. Chauncey Beadle helped young Cornelia plant and tend to a small garden of her own and sent her pressed flowers when she was away. (Courtesy of John Hay Library, Brown University Library.)

GARDEN STAIRS AND ARBOR, SEPTEMBER 23, 1901. Stairs from the lower path of the Shrub Garden lead through the north gate of the Walled Garden. The central path through the vine-clad arbor offers a shady retreat from which to enjoy flower beds and borders. Unlike the gently curving paths in the Shrub Garden, the Walled Garden is formal and symmetrical and laid out in straight lines. (Photograph by Frederick Law Olmsted Jr., courtesy of FLONHS.)

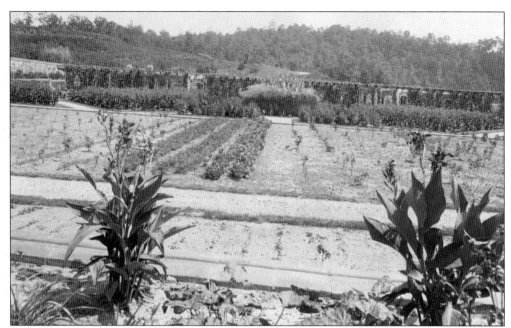

VIEWS OF WALLED GARDEN, C. 1895. Olmsted's vision for the Vegetable and Flower Garden, as he referred to it, was inspired by the kitchen gardens at the great houses in England, which were often walled to protect them from gusting winds and to keep out wild animals. He did not use the term kitchen garden at Biltmore but certainly included the same elements and functionality in his design. He wanted the garden to be a multipurpose garden in that it would provide fresh flowers for the house during the growing season as well as herbs and finer sorts of vegetables and fruits for the Vanderbilts' table. Olmsted entrusted Warren Manning, a young landscape architect working with the firm, to develop the planting list, which included some 30 varieties of fruits, many kinds of vegetables and herbs, perennials, roses, and annuals.

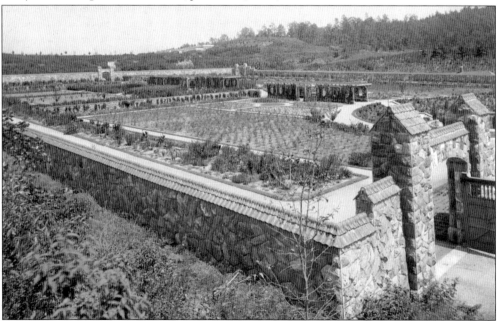

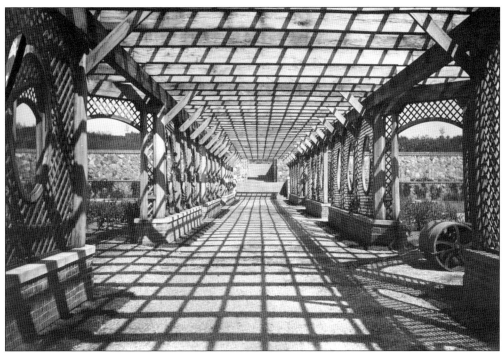

**GRAPE ARBOR IN GARDEN, OCTOBER 15, 1895, AND 1900.** The vine-clad arbor is divided into two sections, each on a different level, totaling 236 feet in length. The arbor spans 18 feet between the foundations and 24 feet in the bays. Besides table grapes trained on the arbor, other fruits, including dwarf apples and pears, cherries, peaches, plums, nectarines, apricots, quinces, figs, pomegranates, Japanese persimmon, currants, and gooseberries were planted in the borders throughout the garden. Fruit trees were grown both as standards and espaliered along the walls. Olmsted consulted with a French firm that specialized in growing and training dwarf fruits and espaliers. As with fruits, varieties of vegetables were selected that were not generally available commercially. (Above, courtesy of FLONHS; right, courtesy of the North Carolina Collection, Pack Memorial Library, Asheville.)

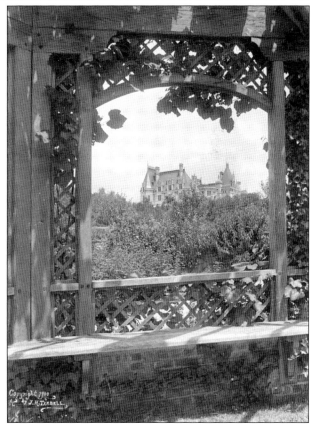

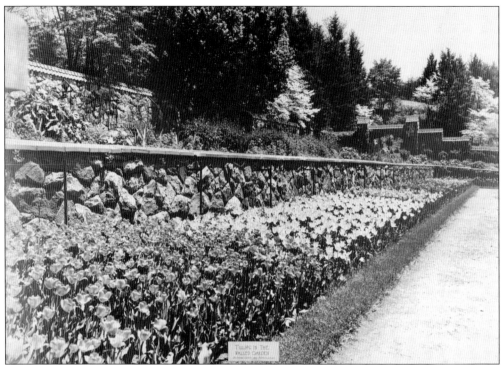

**SPRING BLOOM IN THE GARDENS, 1930.** George Vanderbilt apparently felt that his Truck Farm, or Market Garden, could supply all necessary fruits and vegetables for his table, so he expressed that the Walled Garden should be "a garden of ornament, not utility." Fruits and vegetables continued to be grown in the garden intermittently, but over time most of them were gradually phased out, except for some fruits espaliered along the walls. Various plant lists, orders, and correspondence reveal a wide variety of annuals, perennials, and bulbs that were grown over time in the borders and beds of the garden. Edith Vanderbilt took an active interest in what flowers were being grown in the garden. Seasonal displays of flowers were always standard fare in the Walled Garden but gained new attention when Biltmore House was opened to the public beginning in spring 1930.

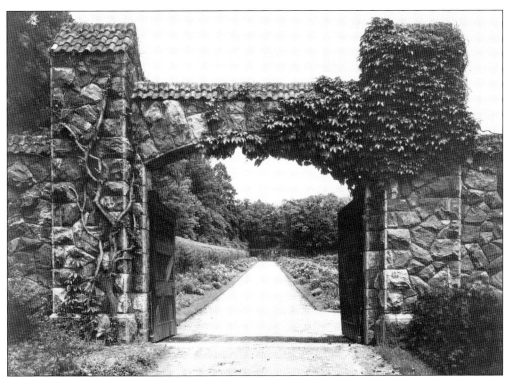

**CARRIAGE DRIVES IN THE GARDEN, 1930.** Olmsted's plans included a main carriage drive passing through the Walled Garden so that George Vanderbilt and his guests could drive their carriages through to view the flowers. Vanderbilt had allowed some public access to various parts of the estate two or three days a week on pass days to see the gardens and grounds long before Biltmore House opened to the public. Locals and out-of-state visitors alike enjoyed the privilege of driving on the estate to see the gardens and grounds in the spring and at other seasons as well. The gardens became widely acclaimed for their floral beauty and stunning seasonal shows of bulbs, annuals, hardy perennials, roses, and azaleas.

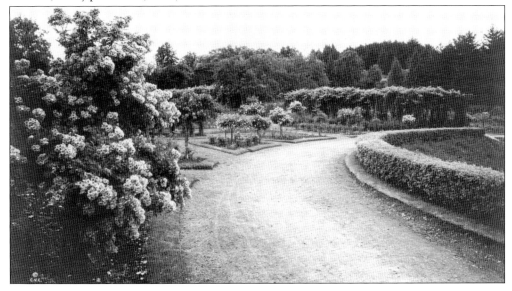

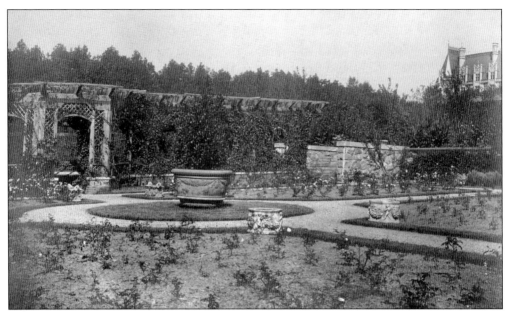

ROSE GARDEN, SEPTEMBER 23, 1901, AND JUNE 1903. Olmsted included a rose garden as part of his plan for the lower part of the Walled Garden as seen in both of these early-1900s views. Roses were a standard offering in the Biltmore Nursery catalog, and the demand grew to the point that the nursery published a 100-page rose catalog featuring a wide array of roses of every form and class being grown. After viewing the new catalog, Chauncey Beadle wrote the publisher, "The book is a realization of our ambitions of many years' standing—to issue a rose catalogue on par with the Biltmore Descriptive Catalogue." With such popularity, the Rose Garden expanded over time to 1.5 acres featuring some 2,000 roses. (Photographs by Frederick Law Olmsted Jr., courtesy of FLONHS.)

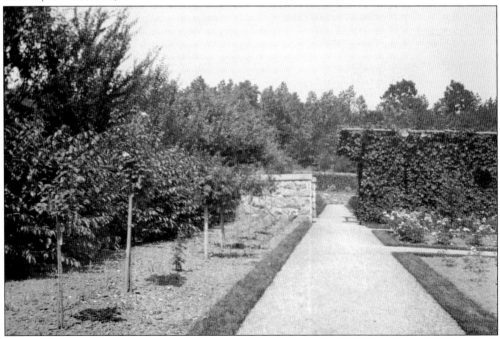

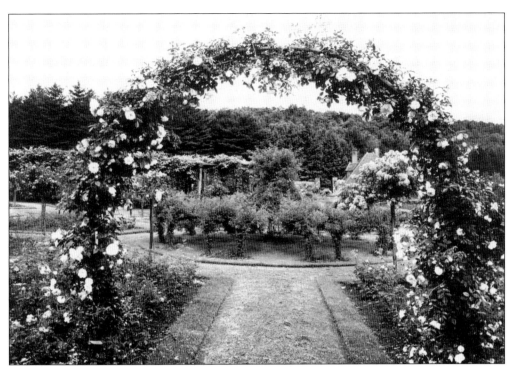

ROSE GARDEN, 1930. Even before Biltmore House was opened to the public, the Rose Garden continued to expand and attract attention. In 1927, Beadle ordered 3,000 roses from two suppliers to plant in the gardens. Then, in preparation for the opening of Biltmore House to the public in 1930, there was a push to beef up the gardens and grounds to a higher standard and degree of showmanship. Special attention was paid to the Rose Garden, with an additional 1,000 roses ordered for spring planting. In early May 1930, Beadle responded to a query about admission to the gardens, saying, "Some local and nearby garden clubs are now planning their regular meeting dates to coincide with the floral parades of the Gardens. For instance, Peonies and Roses will be in their glory in about a fortnight."

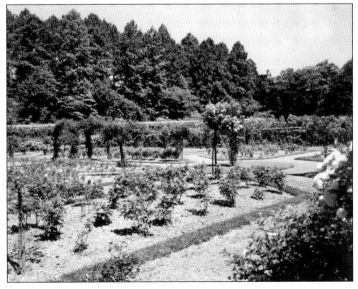

LOVING THE ROSES, C. 1920s. Employees often visited the gardens on Sunday afternoons. Here, James Taylor and some of his family are pictured in the Rose Garden. He came to Biltmore in 1888, married twice, and had 14 children. He worked on the construction of Biltmore House as a handyman and later worked in the landscaping department until eventually becoming head ranger. (Courtesy of Robert Taylor and David Taylor.)

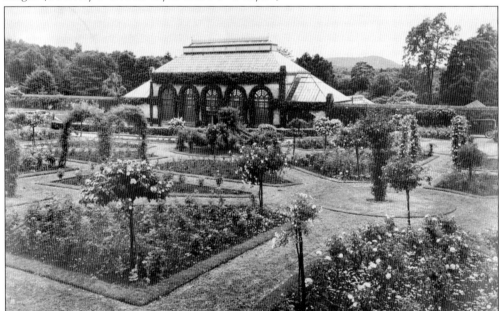

ROSE GARDEN AND CONSERVATORY, 1930. In this view, some of the various classes and forms of roses can be seen—teas, hybrid perpetual roses, polyanthas, ramblers, climbers, pillar roses, standard or tree roses, and others. A maypole with dancers is featured with climbing roses in a circular bed in view of the Conservatory. There was a mirror image of the beds in the other half of the garden.

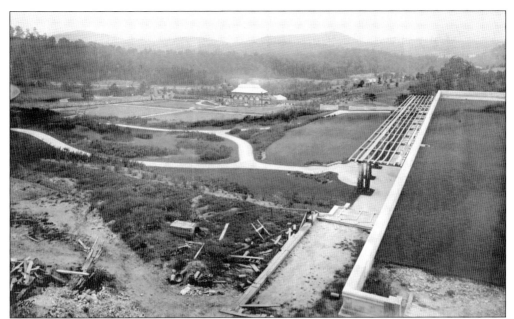

VIEW OF THE GARDENS AND CONSERVATORY, C. 1894, AND WORK YARD, OCTOBER 15, 1895. In a letter to Richard M. Hunt dated March 2, 1889, Olmsted writes, "I think that a good place for glass [greenhouses] can be made east of my winter garden at an elevation about 30' below that of the plateau [Esplanade], the nearest point of it being about 350 ft. southeast of the library window, the roof ridge being well below the line of the eye of those passing along the approaching road and easily planted wholly out of view from the house and the entire entrance plateau, if that is desirable." In the end, the distance of a little more than 900 feet and an approximate 95-foot drop in elevation from Biltmore House and Esplanade to the Conservatory is evident in these images. (Below, photograph by John C. Olmsted, courtesy of FLONHS.)

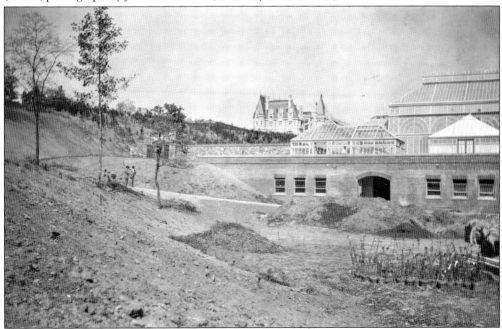

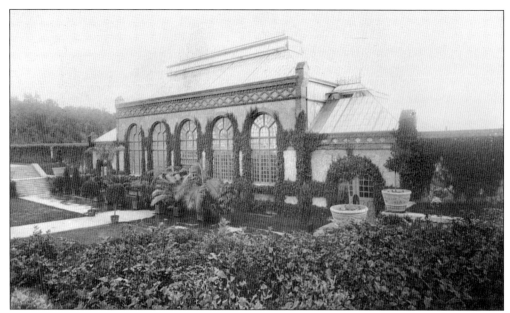

CONSERVATORY, NORTH FACADE, c. 1910, AND SOUTH FACADE, 1900. The architectural design details of the Conservatory were left to Richard Morris Hunt and would conform to the architectural vocabulary chosen for many of the primary outlying structures around the estate and early anchor buildings in Biltmore Village. The north facade with main double-entry doors from the garden and courtyard was ornately constructed with brick quoins and dressings and wall coverings of pebble dash, a type of roughcast stucco of mortar and pebbles that Hunt introduced into the area. A five-part arcade holding grand arched windows with multiple panes allow a preview of the collection of lush palms and other plants housed inside. In contrast to the front facade, the south side of the structure is much less imposing and features the functional and working areas like the gardener's workspace in the basement of the complex.

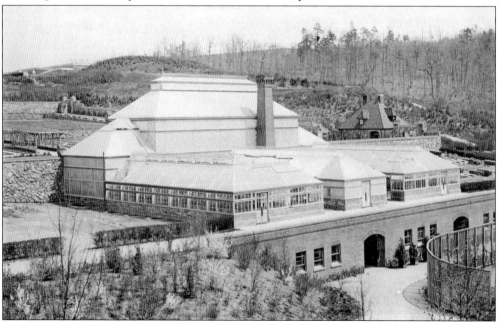

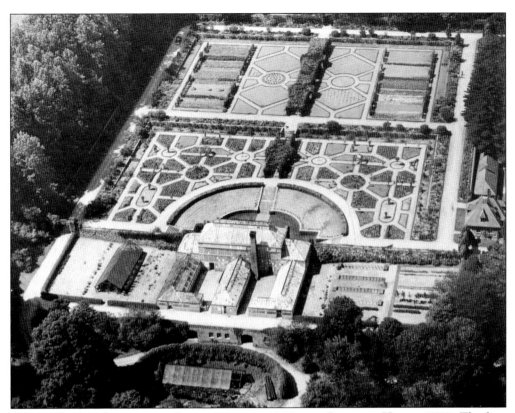

**AERIAL VIEW OF GARDEN AND GREENHOUSES, C. 1950, AND BILTMORE HOUSE, 1900.** The firm of Hitchings & Company, Horticultural Architects and Builders, New York served as consultants on the design of the steel structural frame for the glass covering. The central palm house and wings form the main part of the building, with three wings on the south that were devoted to orchids, roses, and a cool house for azaleas and other plants. Olmsted most likely left much of the planning of functional needs and work spaces of the greenhouse areas to Warren Manning, Chauncey Beadle, and head gardener Robert Bottomley, who had arrived on the scene in the summer of 1892 and moved into the Gardener's Cottage as soon as it was ready. In the above photograph, shade houses and cold frames can be seen on both sides of the Conservatory and below at the basement level.

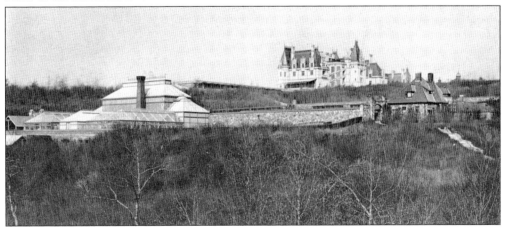

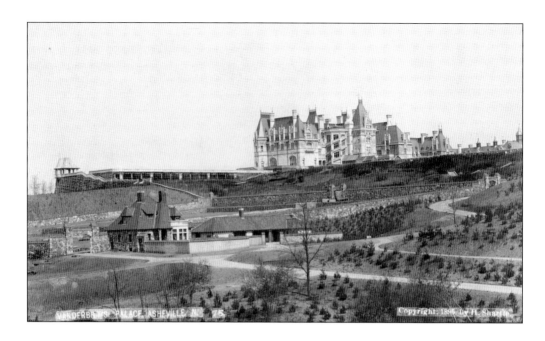

VANDERBILT'S PALACE, 1895. Above, the Gardener's Cottage, completed by early 1893, served as the residence of Robert Bottomley and his family until he left Biltmore in 1903. Bottomley had formerly worked for George Vanderbilt as gardener at the family mausoleum at New Dorp, Staten Island. The stable building consisted of a buggy room, stable boys' room, tool room, stable, and manure room. Below, in mid-February 1895, as the clock ticked toward completion of the house, a plan was made to clear the Esplanade up to 90 feet of space in front of the chateau. The railroad track and switches were removed except for a section on the north drive. By the end of April, the fountain was nearly complete, 18 inches of soil had been spread over the surface, and grass seeded. (Both, photograph by H. Shartle; below, courtesy of FLONHS.)

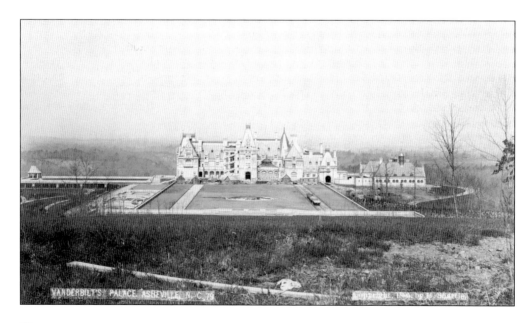

# Five

# THE GLEN AND DEER PARK

With all their charm, the formal gardens and grounds were not the end of the trail. Olmsted intentionally designed paths that continued beyond the Home Grounds into the less-formal areas like the Spring Garden and Glen and the Lake, all of which merged with the wilder spaces around them. Nearly 30 acres of the combined naturalistic landscape of the Spring Garden, Glen, and the Lake, or Bass Pond, were large enough to make the area feel secluded and wild, which is exactly what Olmsted intended. Those who walk its trails and byways still get that sense of a naturalistic setting even though it is in the shadow of the great chateau on the hill. And then there is the Deer Park, which stretches across another 250 acres over hill and vale through meadows of grass and among the gentle groves of trees. Whether on foot, horseback, or bicycle, one can sense Olmsted's touch on the land, a place that is still more under the management of nature than man's hand. Along with the Approach Road, the Glen, Lake, and Deer Park embody the best of who Olmsted was and what he saw and felt when he designed the spaces. Olmsted thought more in decades than years, in lifetimes than moments—for his landscapes were meant to be enduring and not fleeting. Yet for all of that, he also wanted all who experienced them, even for a brief time, to go away with a sense of awe and a renewed spirit.

As work on the forest, arboretum, and grounds progressed, Olmsted expressed to managers in the landscape, gardens, and nursery divisions, "It is a great work of Peace we are engaged in and one of these days we shall all be proud of our parts in it."

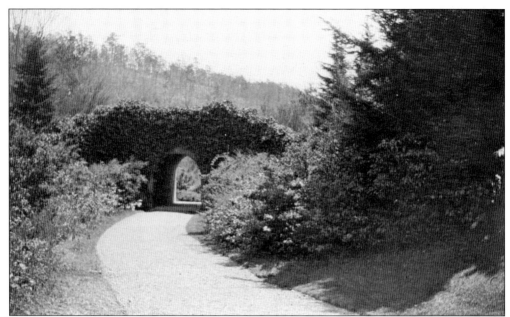

ARCH LEADING TO SPRING GARDEN, APRIL 1907. East of the stairs leading into the Walled Garden, the lower path in the Ramble continues through this brick arch and enters the semi-wild woodland surrounding the Spring, or Vernal, Garden. The circulating path meanders through a planted woodland that appears as if it has always been there. (Photograph by Frederick Law Olmsted Jr., courtesy of FLONHS.)

VIEW OF SPRING GARDEN, C. 1900. The Spring, or Vernal, Garden spreads over a roughly four-acre area that consists of a swath of greensward in a small valley surrounded by a woodland on the higher rim. The slopes radiating up out of the valley are planted with irregular drifts of mostly spring-flowering shrubs. The path around the garden is tucked into the woodland with occasional vistas into the valley. Note the brick arch in upper left.

PATH IN SPRING GARDEN, APRIL 1907. This path through the woodland on the east side of the Spring Garden crosses the exit road from the Conservatory on the lower end of the garden and connects with the path leading into the Glen. Olmsted intended that this area develop a natural or semi-wild character. (Photograph by Frederick Law Olmsted Jr., courtesy of FLONHS.)

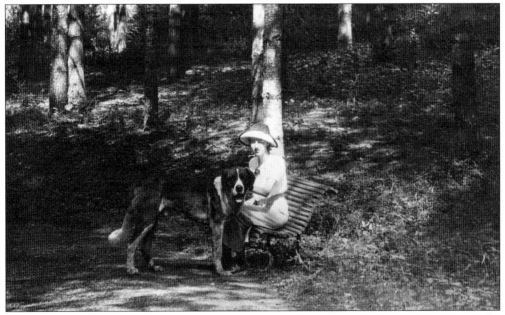

CORNELIA VANDERBILT AND SAINT BERNARD IN SPRING GARDEN, C. 1916. Growing up on the estate, it is no wonder that Cornelia should develop some sense of admiration for her surroundings. From the time she was a small girl, her parents took her on many excursions into the outdoors. Chauncey Beadle also spent time with Cornelia, fishing in the lakes or teaching her about plants and gardening.

WOODLAND PATH IN SPRING GARDEN, C. 1910. A well-developed understory planting is evident in this view. In January 1903, Chauncey Beadle submitted an estimate for a budget appropriation of $400 for the landscape department to purchase rhododendrons, kalmias, and other plants for planting under the pines in the Spring Garden. He also submitted another estimate of $600 for "the first of a series of annual appropriations for the substitution of nicer and more permanent plants, especially evergreens, for the cheap and quick-growing plants originally used in many of the plantations."

**SPRING GARDEN GREENSWARD, APRIL 1907.** A planting plan for the Spring Garden has been referenced in correspondence but has not been located. The Olmsted firm sent a 10-page letter to estate superintendent Charles McNamee with instructions for work to be carried out before summer. Specific instructions included the "Spring Garden District—The grading and draining of this district is to be completed in accordance with sketches and verbal instructions which have been given Mr. Gall. It is important that the ground to be planted with shrubbery and the glade of turf between the two lines of shrubbery should have a rich, deep and well drained soil. If necessary, soil must be obtained from a distance. If this cannot be done at once, it is better that the whole work should be postponed. If it can, the required shrubbery may be planted next Spring." (Both, photograph by Frederick Law Olmsted Jr., courtesy of FLONHS.)

**ROAD BY SPRING GARDEN AND GLEN, 1930.** This road connects the Conservatory and Walled Garden with Glen Road and divides the Spring Garden and its greensward (visible through the young pines) from the Glen in the valley below. In response to a query in 1936, Beadle reported that there were "veritable acres in a Shrub Garden and more acres in a Spring Garden, where vernal flowering woody plants abound."

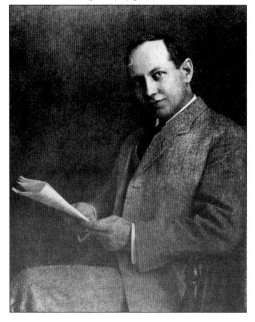

**FREDERICK LAW OLMSTED JR.** Olmsted Sr. was forced to retire because of his failing memory, so it was only fitting that his son and namesake, Frederick Law Olmsted Jr., would become an associate and take over the reins as the firm's representative on the estate. After graduating magna cum laude from Harvard in 1894, "Rick" came to Biltmore at his father's insistence for an apprenticeship. His father considered Biltmore the most important job that he had ever undertaken for a private client. Knowing how his own deficiency in the knowledge of botany had been a handicap, Olmsted felt there was no better place for his son to learn than at Biltmore. He would not have another opportunity to study under such a group of professionals like Chauncey Beadle in the nursery and herbarium, Gifford Pinchot in the forestry department, and James Gall as the firm's resident representative. (Courtesy of RLUNCA.)

**PATH IN THE GLEN, SEPTEMBER 1900.** Located in the valley below the Conservatory, the Azalea Garden is the lowermost of the gardens that descend below Biltmore House. Known as the Glen to Frederick Law Olmsted, it was the largest garden (approximately 15 acres) in his plans and the only one incorporating a brook in its design. The Olmsted firm wrote to Chauncey Beadle in early November 1895 with instructions for gradually thinning out existing trees and replacing with more choice garden varieties. In October 1900, Olmsted Brothers provided Beadle with some details and estimates for preparing his budget for site preparation and planting the Glen. They specified, "Ten thousand shrubs and small trees will be needed and two hundred and twenty-five specimen trees." The detailed planting plan followed in February 1901. (Both, photograph by Frederick Law Olmsted Jr., courtesy of FLONHS.)

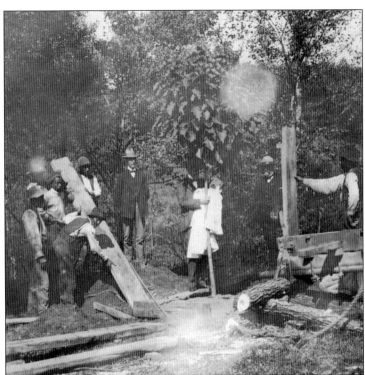

CORNELIA'S TREE, OCTOBER 18, 1900. Chauncey Beadle (left of center) and gardeners watch as two-month-old Cornelia, held by her father, George Vanderbilt, places her hand on the cucumber magnolia tree being planted to honor her birth. Family friend and physician Dr. Samuel Westray Battle (in the Stetson hat) is standing on the right. Edith Vanderbilt is believed to be the photographer. After surviving more than a century, the tree succumbed to decay and was removed in September 2008.

CHAUNCEY BEADLE'S PINETUM, C. 1940. In 1901, George Vanderbilt decided not to move forward with Olmsted's plans for a scientific arboretum, but Beadle continued to add to the plant collections on the estate for nearly five decades. With a goal of 200 species and forms of conifers for the "Pinetum," Beadle had propagated and planted about 100 different ones in the Glen by 1933.

**PATH IN THE GLEN, SEPTEMBER 1900.** Frederick Law Olmsted Jr. visited Biltmore in September 1900 and made notes that would be needed to finalize the planting plan for the Glen. A letter dated October 18, 1900, followed from the Olmsted Brothers with estimates for preparing budget figures for the upcoming plan, which would include 4,000 lineal feet of paths. (Photograph by Frederick Law Olmsted Jr., courtesy of FLONHS.)

**BROOK IN THE GLEN, OCTOBER 15, 1895.** The brook begins as several springs in the upper reaches of the garden and two other springs that are piped underground from the Spring Garden. The brook flows into the Bass Pond at the garden's southern terminus. Notes in the photo album state, "Brook in the Glen just above the pond. Showing the objectionable straightness of the grading." (Photograph by John C. Olmsted, courtesy of FLONHS.)

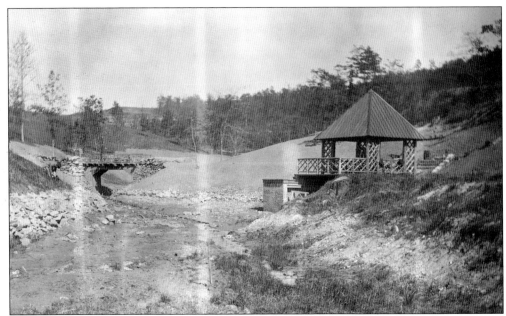

BOATHOUSE AND RUSTIC BRIDGE, OCTOBER 15, 1895. Between 1890 and 1895, Olmsted specified and directed the layout and construction of Glen Road, the Glen, and the Lake, which became known as the Bass Pond. He gave instructions for grading and planting the borders of the road, blocking out and clearing the area of the Glen, and laying out the main paths, which connected the Spring Garden and Conservatory with the Lake. He specified the erection of a rustic wooden bridge crossing the brook where it enters the Lake, the boathouse, and the stone staircase to Glen Road but instructed that R.S. Smith (supervising architect for the Hunt firm) be consulted concerning "the bridge, the staircase, landings, railings, etc." Frederick Law Olmsted Jr. (left) is standing at the intended water level. (Above, photograph by John C. Olmsted; both, courtesy of FLONHS.)

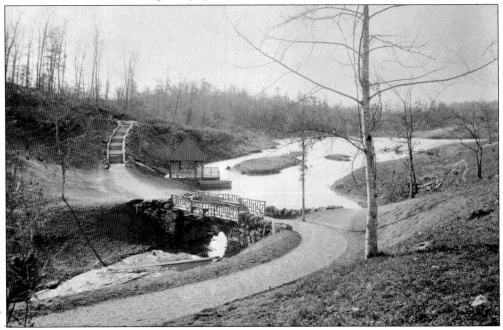

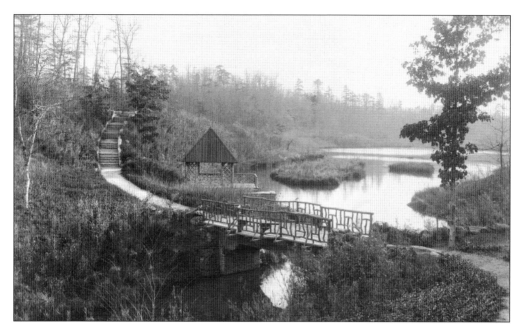

**THE LAKE, OR BASS POND, C. 1895 AND C. 1912.** Olmsted expressed to George Vanderbilt, "There were four reasons for designing the islets near the north margin of the lake: first, the effect of them would be to enlarge the apparent extent of the water . . . and there would at least be more effect of intricacy and mystery; second, [because of] the steepness of the ground almost everywhere at our proposed water-line on the main shore . . . the islands, being low and flat, are intended to serve as a disguise and relief to this circumstance; third, the islands will save cost of construction; fourth, they are needed as breeding places for shy waterside birds, many of which will only make their nests in the seclusion of thickets apparently inaccessible." The photograph below was first published in *Biltmore Photo-Gravures*, H. Taylor Rogers, 1912, Asheville, North Carolina.

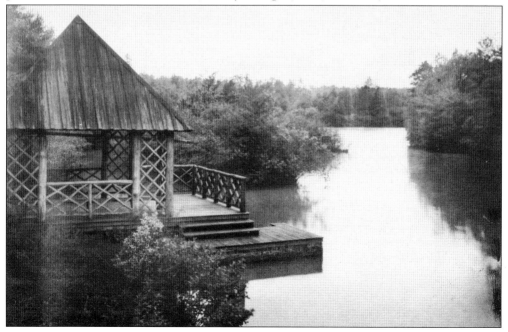

**ALEXANDER MILLPOND, C. 1890, AND BASS POND DAM, C. 1895.** Olmsted described his idea for the new pond: "A dam could be built on the site of the present lower dam of Four Mile Creek and ten feet higher, which would form a lake . . . The pond would cover the site of the old Alexander Mill Pond, a quarter of a mile south of Mr. Vanderbilt's residence. It would be between five and six acres in area. Except where rock should be found, the bottom would have a slope of 2 ft. horizontal to 1 ft. vertical. At the foot of this slope the water would nowhere less than 12 feet deep. In the deepest parts the water would be not less than 20 feet deep." Below, the circular opening is the exit, or mouth, of an ingenious storm flume running under the bed of the pond.

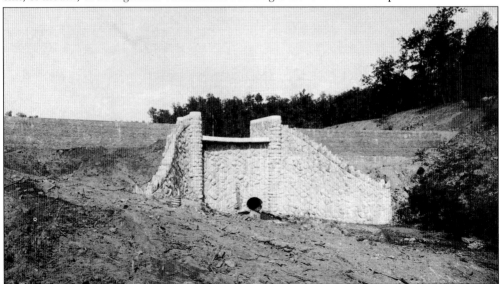

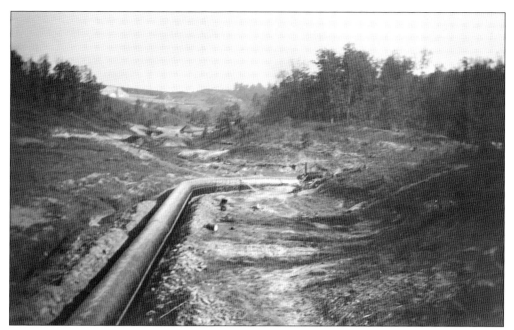

**BASS POND FLUME, OCTOBER 15, 1895, AND BRIDGE, C. 1895.** Olmsted worked with engineer W.A. Thompson to design a brick flume for debris-laden storm water to bypass the pond during periods of flooding. Olmsted explained, "A flume will be constructed on the bottom of the pond, having an outlet below the dam and a funnel-shaped inlet in a pool of Four Mile Creek . . . The mouth of this funnel will be so arranged that on the occurrence of a storm raising the water in the pool, the main volume of the stream will for a time pass through the flume; the intention being that the first wash of the drainage area of the stream above shall thus be carried off without entering the pond." Below, the flume ran under the bridge that crossed the east arm of the pond. (Above, photograph by John C. Olmsted, courtesy of FLONHS.)

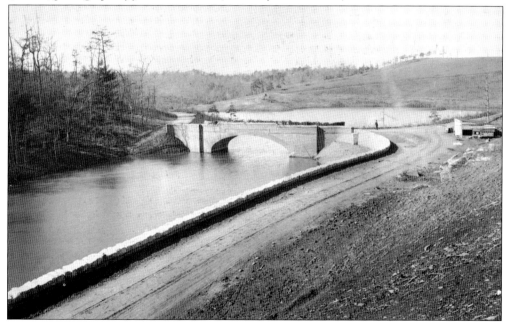

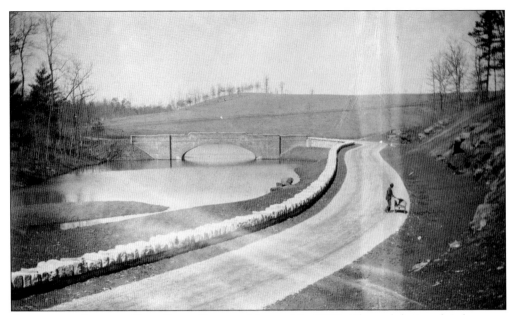

**ARBORETUM ROAD AT GLEN ROAD BRIDGE, MARCH 31, 1896.** Olmsted designed Arboretum Road, which began at the intersection with Glen Road and followed a southerly route to the Arrowhead Peninsula of the French Broad River. After making a loop northeastward to Vanderbilt's Rivercliff Cottage, the scenic drive returned via River Road to Glen Road at the brick farmhouse. (Photograph by John C. Olmsted, courtesy of FLONHS.)

**BASS POND DAM AND WATERFALL, 1930.** Engineer W.A. Thompson worked with Olmsted to design not only the main dam for the Bass Pond, shown here, but also the upper dam at the intake of the flume and the flume itself with its "automatic valve" system. The exit, or mouth, of the flume is visible at the base of the dam on right.

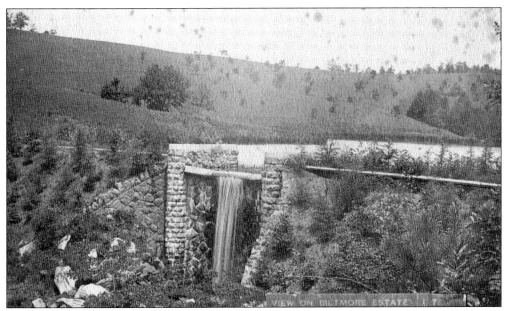

**BASS POND DAM, LATE 1890S.** The main body of the dam with wing walls was artistically designed and constructed out of local stone. Brick foundations support limestone walkways that flank either side of the dam and spillway. The pond can be drained by a manual valve. It is not known when the first rustic bridge was built across the spillway. (Courtesy of Shelburne Farm, Shelburne, Vermont.)

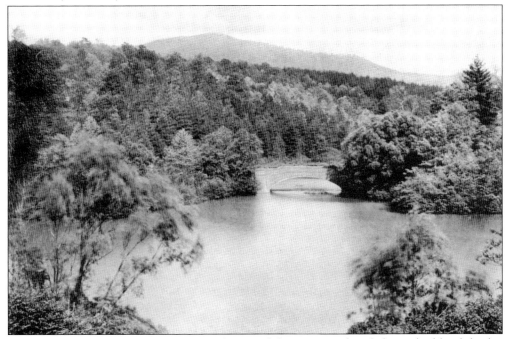

**LAKE AND BRIDGE, C. 1912.** This grand view of the Bass Pond and the arched brick bridge designed by Richard Morris Hunt was taken from the Deer Park on the south side of Biltmore House. The photograph was first published in *Biltmore Photo-Gravures*. Ducker Mountain, once part of the estate, is in the background.

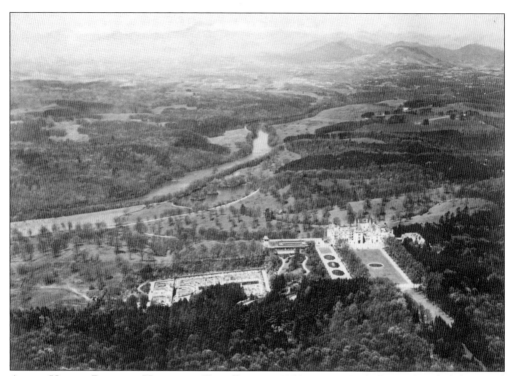

**AERIAL VIEW OF BILTMORE HOUSE AND DEER PARK, C. 1950 AND C. 1905.** George Vanderbilt wanted initially to make a vast park stretching across the hills and valleys along the French Broad River. Olmsted, however, recommended making "a small park in which to view from your house, make a small pleasure ground and garden, farm your river bottom chiefly to keep and fatten livestock . . . And make the rest a forest, improving the existing woods and planting the old fields." In a report presenting his views, Olmsted explains, "There is no park-like land on the Estate. None in which park-like scenery of a notably pleasing character could be gained in a life time." However, he notes there was "plenty of land in which agreeable wild, woodland scenery can be had in a few years."

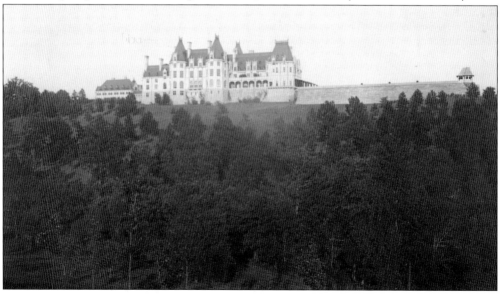

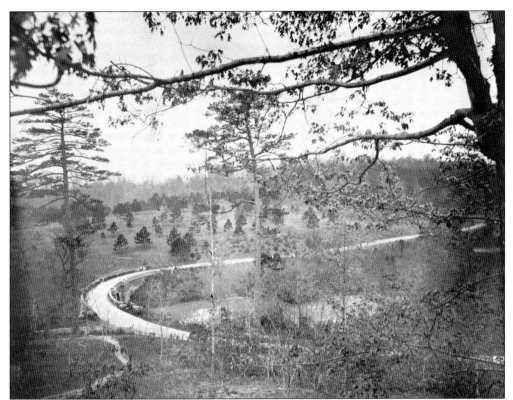

**SERVICE ROAD, MAY 8, 1894.** The Service Road, which ran from the estate's entrance to the servant's courtyard and stables at Biltmore House, was most likely the first new road completed on the property. After cresting the ridge above the Swannanoa floodplain, the road dipped into a narrow valley before making a steep ascent to the north end of the house. Two brick bridges were necessary to cross a couple of ravines, and both were completed by the end of October 1891. A small pond was created above the first and highest bridge that could be accessed by a path from the stables at the house. A road initially known as Deer Park Road (now Pony Road) was constructed in 1899 and ran from River Road through the valley of the park immediately west of Biltmore House to the Service Road near the midway at the first bridge.

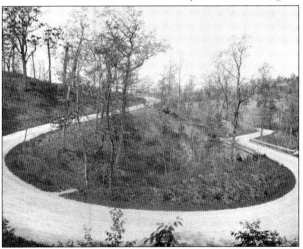

**TREE THINNING IN DEER PARK, JUNE 1903.** The earliest thinning, carried out during 1890 and 1891 in the area designated as the Deer Park, was to remove dead trees, overgrowth of scrub pines, and other species that were undesirable as park trees. The thinning in this photograph was for removal of excess trees that were planted to establish the park. (Photograph by John C. Olmsted, courtesy of FLONHS.)

**DEER PARK, MAY 1905.** Olmsted suggested to George Vanderbilt, "The park would differ from the forest in having a much larger proportion of unwooded ground; in having a larger proportion of its trees standing singly and in groups; in being more free from under wood; and in having a turf surface, forming a fine pasture and giving a pleasant footing for riding or walking freely in all directions." (Photograph by Frederick Law Olmsted Jr., courtesy of FLONHS.)

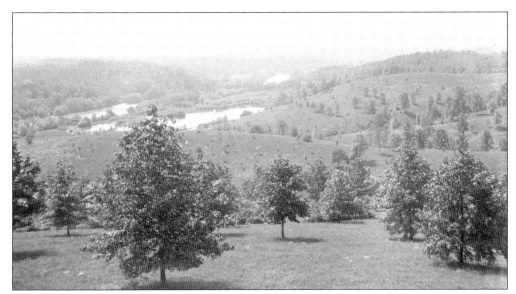

**DEER PARK, MAY 1905.** "A park that would answer every desirable purpose would not, I think, exceed two hundred and fifty acres. If much larger it would be a worrisome business to take care of it and the needed fences, gates and other requirements of keeping would be inconvenient. The central parts of it would be nearly midway between the residence and the river." (Photograph by Frederick Law Olmsted Jr., courtesy of FLONHS.)

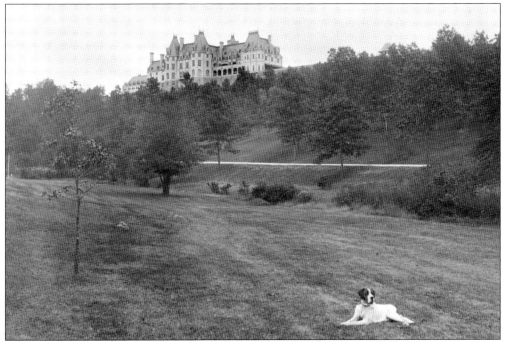

**SAINT BERNARD IN THE DEER PARK, C. 1905.** On December 4, 1894, Olmsted sent the following instructions to Charles McNamee: "Pits ten feet across and three feet deep are to be made ready for these [trees] and enough good soil and compost is to be placed near them to refill the pits. This work is to be under the direction of Mr. Beadle . . . spare no pains to secure the highest success for this very important planting."

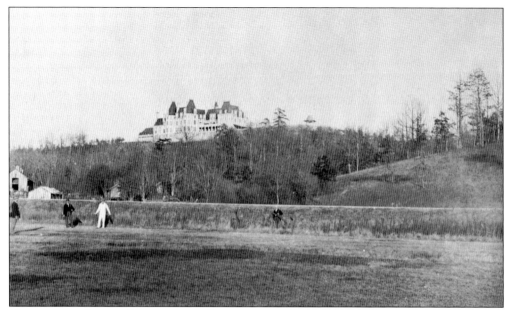

UNIDENTIFIED GUESTS GOLFING IN THE PARK, C. **1896.** On Christmas Eve 1895, George Vanderbilt welcomed family and friends to celebrate the opening of Biltmore House with him. For some of his guests who stayed to usher in the New Year, Vanderbilt had arranged a variety of activities such as riding, hunting, and golf. Letters record rousing golf matches played almost daily throughout the holidays. He commissioned Newport professional golfer Willie Davis to lay out a nine-hole course between the brick farmhouse and the Lagoon. The golf links were soon expanded into the Deer Park west of the house and required an annual budget of $2,000. In October 1898, Beadle wrote to farm manager George Weston stating Vanderbilt ordered the golf links mowed and placed in playing condition and requested cows be kept out of putting greens and parks. (Both, courtesy of Lila Wilde Berle.)

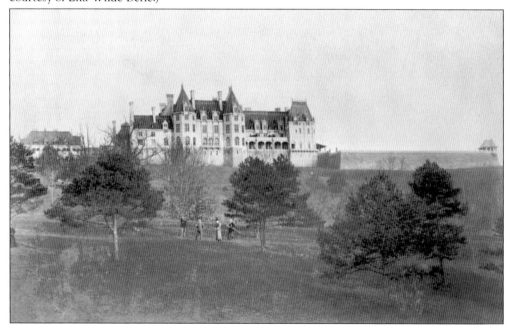

THE LAGOON, C. 1900. In March 1894, Charles McNamee asked engineer W.A. Thompson to put on paper a plan and cost estimate for the proposed Lagoon at the sand pits as well as to stake out the location. Thompson complied and sent a topographical map and details of his calculations to Olmsted. In order to have the minimum depth of five feet of water, it would be necessary to excavate 17,000 cubic yards of soil to create the dikes forming the Lagoon. Preliminary work of clearing and preparing the site began in summer of 1894, but excavation did not get underway until summer 1897. Stocked with black bass, the Lagoon covers about six acres and was a favorite destination for the Vanderbilts and their guests. Beadle wrote Edith Vanderbilt in May 1908, "I have an appointment with Miss Cornelia this afternoon at the Lagoon, and I trust that the fish will be very attentive."

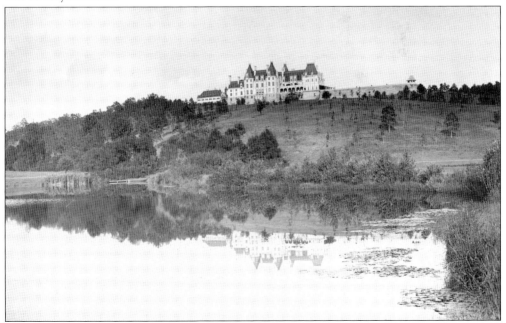

RIVER ROAD, C. 1894, AND FERRY ROAD JUNCTION, C. 1900. Olmsted planned a system of carriage drives on the estate that were scenic as well as functional. All primary roads had macadam surfaces created by forming top layers of crushed stone with the screenings or fines over bases of coarse aggregate. When wet and compacted with rollers, the drives provided smooth firm surfaces for carriages and wagons. River Road passes between an overhanging rock precipice known as Big Rock and the French Broad River on the way from the Lagoon to Ferry Farm and the Dairy. The estate roads are named and labeled on the 1896 guide map of Biltmore Estate. Below, River Road intersects with Ferry Road to the right and Dairy Road to the left. This intersection marks the transition from the primarily ornamental landscape of home grounds, gardens, and park to the working agricultural and forested areas of the estate.

*Six*

# A MODEL FARM AND FOREST

The story of Biltmore's agricultural and forestry history is so vast and complex that this book cannot attempt to do it justice or give the coverage it deserves. The main focus of this work is on the landscaped gardens and grounds. Thus, this chapter is intended to only give a brief introduction to this amazing part of Biltmore's history and highlight a few points of interest. In Frederick Law Olmsted's 36-page report that summarizes his early thoughts for Biltmore, he advises George Vanderbilt, "You know that what passes with us as 'gentleman farming,' is generally a very costly, and that after a time, it usually comes to be a very unsatisfactory, amusement. Why should you undertake farming on any large scale? The only reason that I can see is that to a rapid improvement of the Estate as a forestral country seat you need to have at command a great deal more manure than you can economically obtain except by a certain kind of farming. Adopting this as the real motive of what you shall do, incidentally you will have the pleasure of raising and keeping as much fine stock of all kinds as you choose. Considering fine stock as an incidental feature of your operations, to which you can give as much attention as you please, (making the Estate famous as a head-quarters for particular herds and strains, if your inclination ultimately runs that way), the main agricultural question is how to maintain a large stock most economically."

Olmsted seemed determined to make Biltmore a model of forestry for the country and in many ways felt that it was the most important part of his recommendations to Vanderbilt. After surveying Vanderbilt's land holdings, Olmsted prepared reports in 1889 and 1890 describing the condition of the existing forest along with detailed suggestions for improvement and reforestation of worn-out hillsides not suitable for farming. Olmsted noted, "The management of forests is soon to be a subject of great national, economic importance, and as the undertaking now to be entered upon at Biltmore will be the first of the kind in the country to be carried on methodically, upon an extensive scale, it is even more desirable than it would otherwise be that it should, from the first, be directed systematically and with clearly defined purposes, and that instructive records of it should be kept." Olmsted's ideas of combining the economical, or utilitarian, aspects of forestry with the aesthetics or landscape effect were ahead of their time.

VANDERBILT'S HERD OF JERSEYS, 1906. A dairy had been established on the estate in 1890, and by 1891, farm manager Baron d'Allinges had negotiated the first milk contract. Agricultural consultant Edward Burnett purchased a stock herd of registered Jerseys in Vermont to bring to Biltmore. In time, the Biltmore Jersey herd became the largest and most famous in North America. This image was originally published in *Views of Asheville and Biltmore* for S.H. Kress & Company.

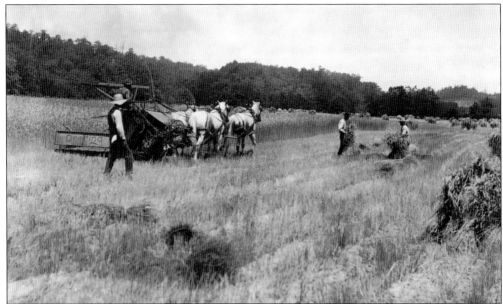

HARVESTING GRAIN, C. 1900. The establishment of commercial livestock farms with a large herd of Jersey cattle, Berkshire hogs, flocks of Southdown sheep, and various breeds of poultry—chickens, turkeys, and geese—would require enormous quantities of grains such as oats, barley, corn, and others to supply the necessary feed and bedding. In this scene, farmhands are harvesting one of the cereal grains and binding the sheaves from the harvester into shocks for curing.

POULTRY FARM, C. 1906, AND TRUCK FARM, 1900. An article about Biltmore Farms published in *North Carolina and Its Resources* by the State Board of Agriculture in 1896 states, "The latest addition to the farms is an extensive Poultry Department. Its object is twofold. First, the production of broilers, eggs, etc., for the table of the owner; secondly, the improvement of the common barnyard fowl of the South by the introduction of better stock." Breeds included Gold and Silver Wyandottes, Barred and White Plymouth Rocks, Light Brahmas, Buff Cochin, and Indian Games. "In the market gardens a call for high-class vegetables and small fruits has been met (a demand which is heaviest during the winter months), by the erection of a very complete group of buildings, comprising forcing houses, storage and root houses, office, carpenter-shop, shipping shed, etc. This department is conducting an extended series of tests of the varieties of vegetables and small fruits most suitable to this region." (Above, courtesy of RLUNCA.)

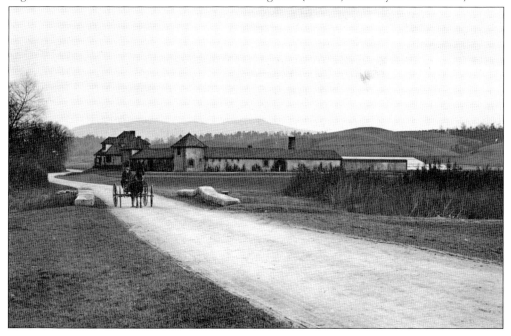

**BARNS AT RIVER BEND FARM, SEPTEMBER 1900.** A number of barns, outbuildings, and farmhouses scattered over the estate were present on the many small farms and tracts of land that Vanderbilt purchased. The best of these were utilized until new buildings, suited for specific purposes, were constructed. These substantial barns were on River Bend Farm, sold to Vanderbilt by James G. Martin and used until the new dairy and horse barn and stables were constructed. (Photograph by Frederick Law Olmsted Jr., courtesy of FLONHS.)

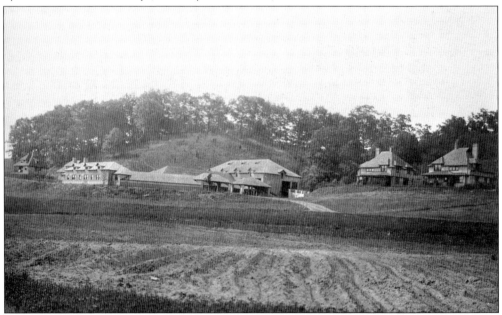

**HORSE BARN AND STABLES, JUNE 1903.** This barn complex was completed in 1902 to house the teams of draft horses and mules that worked the land and pulled delivery wagons. The main barn with three levels and the adjoining covered sheds were the center of operations and a social center for farm employees and their families, who lived in the comfortable cottages nearby. (Photograph by Frederick Law Olmsted Jr., courtesy of FLONHS.)

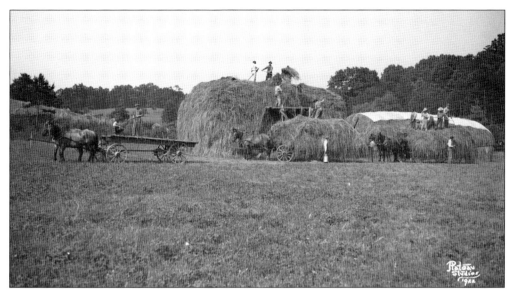

**HAYING TIME, 1922.** It took a tremendous amount of hay for the supplemental feeding of horses, mules, cows, and sheep, particularly in the winter months. It was possible to get three or sometimes four cuttings a season if the growing conditions were good. Loose hay like this was often kept in large stacks in the field, and higher-quality hays like alfalfa were cured and stored in barns. (Courtesy of RLUNCA.)

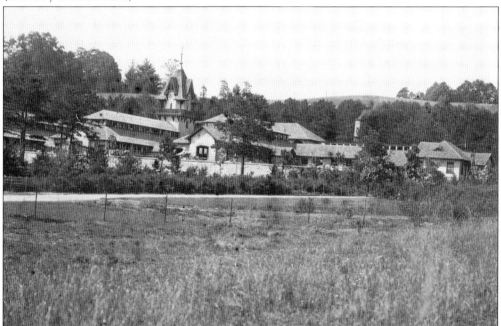

**MAIN DAIRY BARNS, JUNE 1903.** The main dairy barn, completed in 1902, was designed to house 140 milking cows, a maternity section, a hospital for sick cows, a calf barn, and space for five bulls. Biltmore Dairy incorporated the highest standards of sanitation, employed a resident veterinarian, and was the first certified dairy in the South. The landscape department installed an extensive landscape of ornamentals designed by Olmsted Brothers. (Photograph by Frederick Law Olmsted Jr., courtesy of FLONHS.)

**PINE PLANTATIONS NEAR JUNCTION OF APPROACH AND SERVICE ROADS, MARCH 27, 1896.** Olmsted prescribed the reforestation of hundreds of acres of land that had been previously cleared and worn out from decades of overgrazing and farming. The Eastern white pine was used extensively for reclaiming the land because of its ability to flourish in poor soil conditions, although nearly 30 species were planted for reforestation projects. (Photograph by John C. Olmsted.)

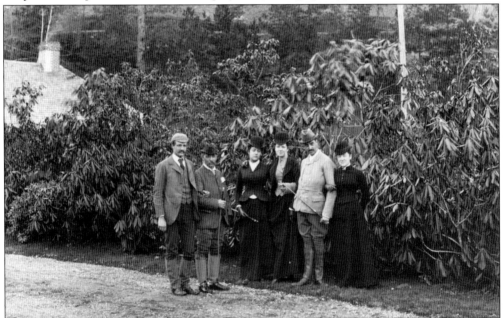

**GEORGE VANDERBILT WITH FAMILY AND FRIENDS, C. 1892.** Gifford Pinchot, Biltmore's first forester, developed at Biltmore the first comprehensive and sustainable forest-management plan on a large scale in the United States. In 1898, Pinchot was appointed head of the Division of Forestry in Washington and became the first chief of the US Forest Service in 1905. Pictured here are, from left to right, Gifford Pinchot, George's cousin-in-law Walter R. Bacon, nieces Adele and Emily Sloan, George Vanderbilt, and his cousin Virginia Barker Bacon.

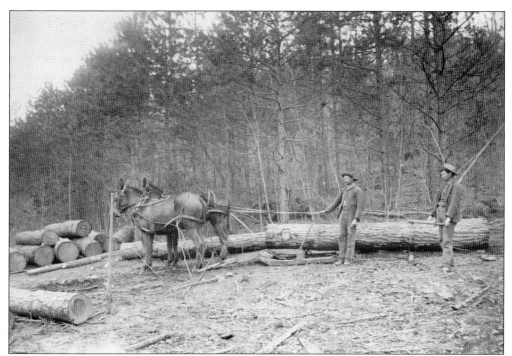

LOGGING AND PORTABLE SAWMILL, C. 1892. The "Biltmore Working Plan" prepared by Pinchot had three primary objectives: profitable production, a nearly constant annual yield of forest products, and an improvement in the condition of the forest. Even under trying conditions, his working plan would prove that forestry could be profitable while improving the overall health and condition of the forest. Pinchot published *Biltmore Forest. The Property of Mr. George W. Vanderbilt. An Account of its Treatment and the Results of the First Year's Work* in 1893.

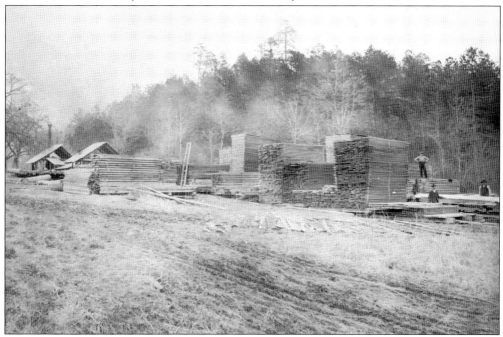

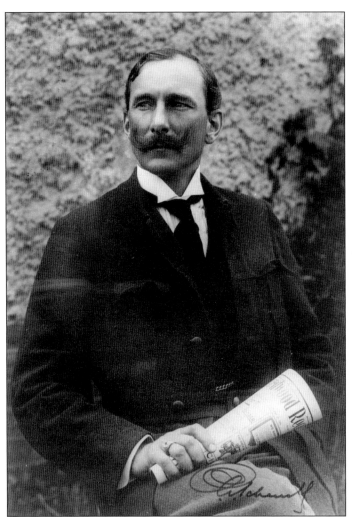

**DR. CARL A. SCHENCK.** In 1895, German forester Dr. Carl Alwin Schenck succeeded Pinchot as Biltmore's chief forester. During his 14-year tenure at Biltmore, Schenck devised a comprehensive management plan and implemented selective harvest systems and experiments in Vanderbilt's extensive Pisgah Forest tracts as well as continuing the management and improvement of Biltmore Forest that was begun by Olmsted and Pinchot. He established the Biltmore Forest School, the first in the United States to train professional foresters. (Courtesy of RLUNCA.)

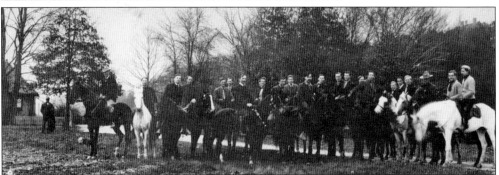

**BILTMORE FOREST SCHOOL STUDENTS, C. 1908.** Dr. Schenck, seventh man mounted from left, ran the school with a firm but caring hand. His students had a great respect and admiration for him and developed a great esprit de corps. Winter classes were held in the forester's office at the Swannanoa Gate Lodge visible on left, and summer classes were in Vanderbilt's Pisgah Forest at the Pink Beds. The course of study was one year with a six-month apprenticeship. (Courtesy of RLUNCA.)

**UPPER FERRY ON FRENCH BROAD RIVER, C. 1906.** Two ferries on the French Broad River provided transportation to and from the west side of the estate for both the farm and forest departments as well as for George Vanderbilt and his guests. One of the students in the Biltmore Forest School class of 1906 is pictured here with the ferryman and his assistant. The students referred to themselves as "Schenck's Rough Riders." (Courtesy of Guy K. Gooding II.)

**FOREST FESTIVAL, 1908.** Dr. Schenck hosted a three-day forest festival during Thanksgiving week in 1908 to celebrate 20 years of forestry at Biltmore. Attendees, including foresters, lumbermen, and politicians, are shown here touring the Long Ridge plantations overlooking the Market Garden and Swannanoa bottomlands. Schenck planted more than 30 species of trees on the steep slopes of former worn-out pastures before achieving success. (Photograph by George Butz, courtesy of RLUNCA.)

**DOUGLAS PLANTATIONS, C. 1916.** Olmsted asked Robert Douglas & Sons Nursery in Waukegan, Illinois, in 1890 for a proposal to plant several hundred acres with white pine. The Douglas plantations were the first trees planted on the estate to fulfill Olmsted's plan for reforesting hundreds of acres of worn-out land. The tracts are in various locations on the estate, including this area adjacent to the old Ferry Road. (Courtesy of RLUNCA.)

**WHITE PINE PLANTATION, LATE 1920S.** Estate superintendent Chauncey D. Beadle endorsed a cooperative project with the US Forest Service begun in 1916 to conduct a number of experiments in many of Biltmore's plantations, such as this one planted by Schenck in 1899. The Southeastern Forest Experiment Station, established in 1921, continued the research to study the effects of periodic thinning on growth rates and yield until 1970. (Courtesy of RLUNCA.)

*Seven*

# A Tribute to Chauncey Beadle

Chauncey Delos Beadle, born in St. Catharines, Ontario, Canada, on August 5, 1866, devoted most of his life and career, 60 years, to Biltmore Estate in a variety of capacities and roles. Trained in botany and horticulture at the Ontario Agricultural College and Cornell University, he was hired first in 1890, on a temporary basis, to supervise the Biltmore Nursery under landscape and forest manager James Gall Jr. Beadle's responsibilities included collecting and purchasing nursery stock, propagation and growing an inventory of ornamental plants to be used in implementing the extensive planting plans produced by the Olmsted firm for Biltmore's Home Grounds and Gardens, the Deer Park, miles of roadside plantings, outlying residences and facilities, and the Biltmore Arboretum and Herbarium. In 1894, the Biltmore Nursery was made a separate department, and Beadle was promoted to superintendent, responsible for the nursery and all planting operations. With time, he took on more and more responsibility, and when estate superintendent Charles McNamee left the estate in 1903, Beadle assumed that role. Beadle handled a lot of business and personal affairs for both George and Edith Vanderbilt. His role as estate superintendent was one of general business manager of all operations. He was trusted in a variety of capacities by George Vanderbilt, one of which included managing Vanderbilt's more than 40 rental cottages and a number of business leases and contracts. Beadle also managed the family's fleet of automobiles. After her husband's death, Edith Vanderbilt and the other trustees of George Vanderbilt's estate relied heavily on Beadle for keeping the estate running and solvent. He managed the sale of the former Biltmore Nursery premises to Southern Railway and Biltmore Village to the Appalachian Realty Company. He served as landscape architect for the Biltmore Estate Company in the development of the town of Biltmore Forest. During the years Biltmore Nursery operated as a commercial business, Beadle developed landscape plans for businesses, real estate developers, and private residences and sold the plant materials to implement them. He was a nationally known and highly regarded botanist and taxonomist and published several critical works. The list could go on, but perhaps most importantly, Beadle was the common denominator, the continuum that spanned more than a half century of Biltmore's operations from the establishment through the founder's death, two world wars, the Great Depression, the changing of the guards in the Olmsted firm, and beyond. All of this and he still devoted time and kindness to young Cornelia Vanderbilt, helping her cultivate an interest in plants, gardening, and other outdoor pastimes. Beadle's life at Biltmore must have been good, and he liked to sum it up by telling people, "I came for a month but stayed for a lifetime."

**CHAUNCEY AND MARGARETTA BEADLE, 1906.** Chauncey Beadle and his first wife, Margaretta, are heading out on a drive from Eastcote, the residence Vanderbilt had constructed for Beadle in the early 1900s. Beadle remained living at Eastcote until his death in 1950. In addition to Eastcote, Beadle maintained a home near Miami, Florida, and a property with private nursery just east of Asheville. (Courtesy of Jeanette Angel.)

**CHAUNCEY BEADLE (LEFT) AND GEORGE VANDERBILT, APRIL 1907.** Chauncey Beadle and George Vanderbilt are at their luncheon place on the Ridge Trail in a cove on Bent Creek watershed. From the early 1900s until his retirement, Beadle managed the Buckspring Lodge property on Mount Pisgah for the Vanderbilts. He oversaw the construction of the Pisgah automobile road in 1910 and 1911 and negotiated the sale of Pisgah Forest to the federal government. (Photograph by Frederick Law Olmsted Jr., courtesy of FLONHS.)

SYLVESTER OWENS, EDITH VANDERBILT GERRY, AND CHAUNCEY BEADLE, C. 1940. This photograph may have been taken when Edith was in town for the dedication of the Azalea Garden in honor of Beadle's 50 years of faithful service. Sylvester Owens (left) was Beadle's trusted assistant and chauffeur for many years and drove Beadle and his fellow "Azalea Hunters" for thousands of miles in their pursuit of rare azaleas and other native shrubs and plants.

CHAUNCEY BEADLE ADMIRING AZALEAS, 1948. Beginning his new hobby at age 62, Chauncey Beadle and botanist friends Frank Crayton and William Knight, along with Sylvester Owens as driver, also known as the Azalea Hunters, spent countless hours over long weekends and holidays driving through every Southeastern state searching for every species, natural hybrid, form, and color of native deciduous azaleas. These expeditions took place on their personal time and spanned a decade and a half from 1930 to 1945.

CHAUNCEY BEADLE IN AZALEA GARDEN, 1948. Beadle maintained his personal collection of azaleas at his farm on the east side of Asheville until 1940. He knew that he needed to find a home for his 20,000 "children" before he became too old to care for them. He could think of no better home than the Glen in the valley below the Conservatory and gardens. Edith Vanderbilt Gerry and the Biltmore Company president Junius G. "Judge" Adams agreed.

AZALEA GARDEN DEDICATION, APRIL 1, 1940. In honor of his then-50 years of service to Biltmore, the estate held a celebration for Chauncey Beadle on April 1, 1940, in the Glen, which from that day forward would be called the Azalea Garden. All employees of the estate, including those from the Dairy and their spouses, were invited for the 6:00 p.m. event, which included a picnic. The setting was in the Pinetum (conifer collection) that Beadle had established a few years before.

**AZALEA GARDEN DEDICATION, APRIL 1, 1940.** Edith Vanderbilt Gerry (in center), Chauncey Beadle (with back to camera), and five gentlemen are standing near the bronze marker in the Azalea Garden during a dedication ceremony honoring Beadle's 50 years of service to Biltmore Estate. Nine other employees who had been with the estate for 40 or more years were honored also.

**EDITH GERRY AND CHAUNCEY BEADLE, APRIL 1, 1940.** During the ceremony, Beadle spoke briefly, and company president Judge Adams, presiding as master of ceremonies, presented Beadle with a check for $5,000 toward publishing a book on azaleas, which unfortunately did not come to fruition. Other gifts included a watch from Edith Gerry and luggage from fellow employees. Gerry unveiled the marker that memorializes Beadle's lifetime of faithful service and gift of his azaleas to Biltmore Estate.

127

# DISCOVER THOUSANDS OF LOCAL HISTORY BOOKS FEATURING MILLIONS OF VINTAGE IMAGES

Arcadia Publishing, the leading local history publisher in the United States, is committed to making history accessible and meaningful through publishing books that celebrate and preserve the heritage of America's people and places.

Find more books like this at
**www.arcadiapublishing.com**

Search for your hometown history, your old stomping grounds, and even your favorite sports team.

Consistent with our mission to preserve history on a local level, this book was printed in South Carolina on American-made paper and manufactured entirely in the United States. Products carrying the accredited Forest Stewardship Council (FSC) label are printed on 100 percent FSC-certified paper.

MADE IN THE

USA